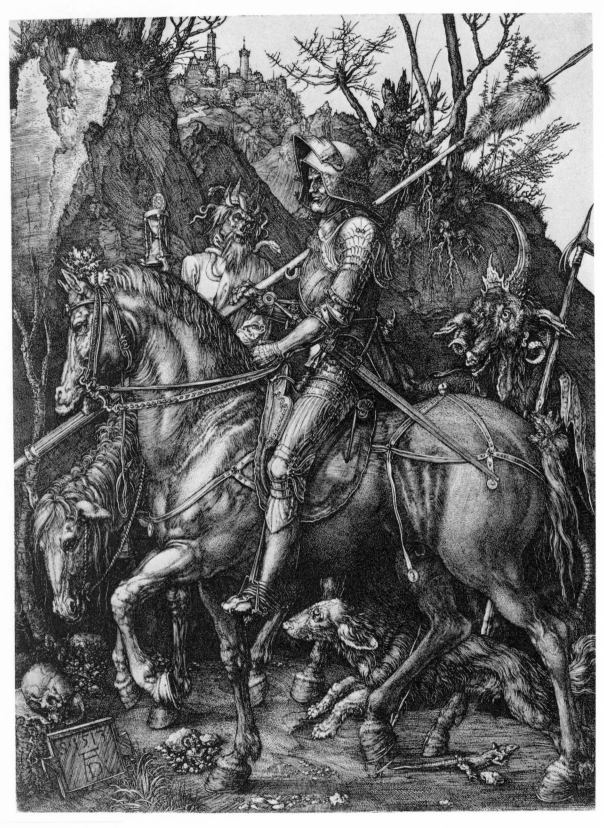

"Knight, Death and Devil." Engraving by Albrecht Dürer, Nuremberg, 1513.

DOVER *Pictorial Archive* SERIES

Devils, Demons, Death and Damnation

ERNST AND JOHANNA
LEHNER

DOVER PUBLICATIONS, INC.
NEW YORK

Published in Canada by General Publishing Company, Ltd., 30 Lesmill Road, Don Mills, Toronto, Ontario.
Published in the United Kingdom by Constable and Company, Ltd., 10 Orange Street, London WC 2.

Devils, Demons, Death and Damnation is a new work, first published by Dover Publications, Inc., in 1971.

DOVER *Pictorial Archive* SERIES

Devils, Demons, Death and Damnation belongs to the Dover Pictorial Archive Series. Up to ten illustrations from this book may be reproduced on any one project or in any single publication free and without special permission. Whenever possible, include a credit line indicating the title of this book, author and publisher. Please address the publisher for permission to make more extensive use of illustrations in this book than that authorized above.

The republication of this book in whole is prohibited.

International Standard Book Number: 0-486-22751-0
Library of Congress Catalog Card Number: 72-137002

Manufactured in the United States of America
Dover Publications, Inc.
180 Varick Street
New York, N. Y. 10014

CONTENTS

1. Mors, the Angel of Death. After a miniature in an Anglo-Saxon manuscript, tenth century.

LIST OF ILLUSTRATIONS

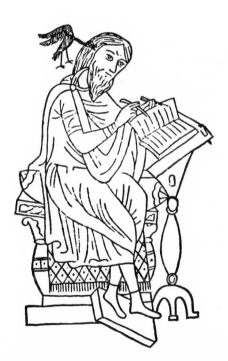

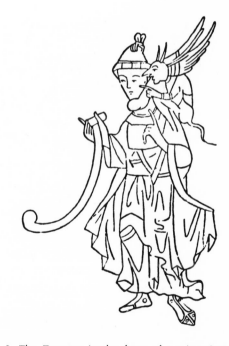

2. The Evil Spirit figured as a black bird whispering into the ear of a magician. From a French manuscript *Hortus Deliciarum*, eleventh century.

3. The Tempter in the form of a winged serpent whispering into the ear of St. Martin. After a Saxon manuscript *Legend of St. Martin*, eleventh century.

4. Demonic grotesque initial T. After a French calligraphic manuscript, twelfth century

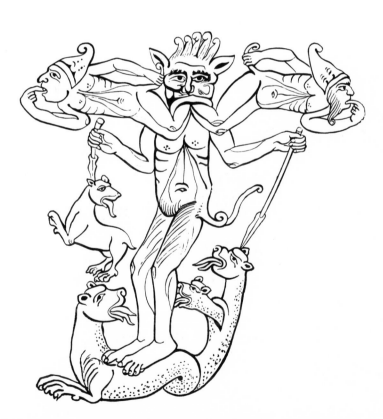

5. Demonic grotesque initial T. After a French calligraphic manuscript, the *Rouleau mortuaire de Saint Vital,* twelfth century.

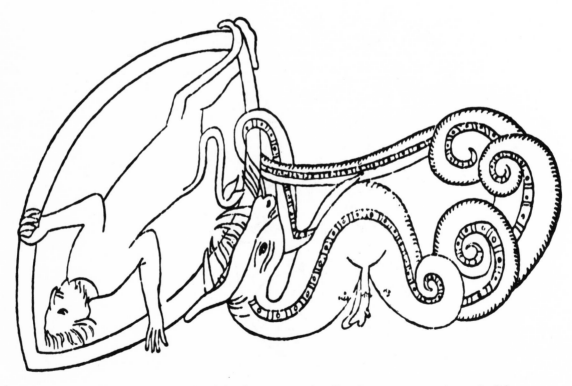

6. The Evil Spirit swallowed by the Dragon of Hell. After a miniature in an English manuscript, twelfth century.

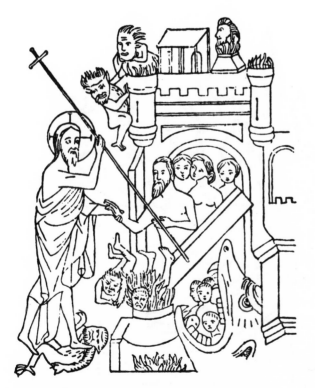

7. Jesus Christ breaking down the gates of Purgatory. After a miniature in a French manuscript, thirteenth century.

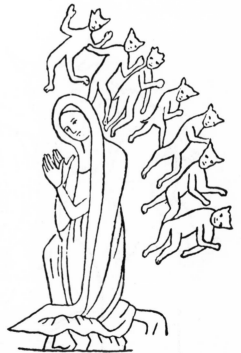

8. Possessed woman, praying, is redeemed from the Demons of the Seven Deadly Sins. After a miniature in an English manuscript Bible, thirteenth century.

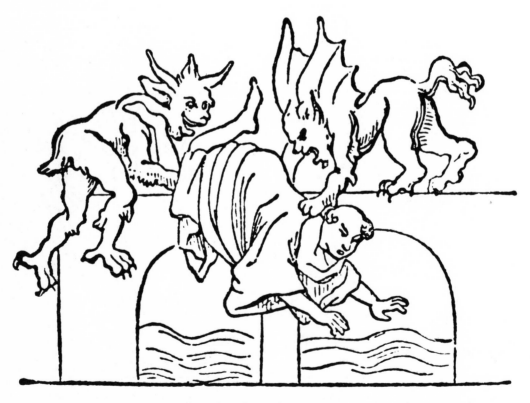

9. Demons drowning a monk in the Tiber. After a miniature in an Italian manuscript "Moral Bible," thirteenth century.

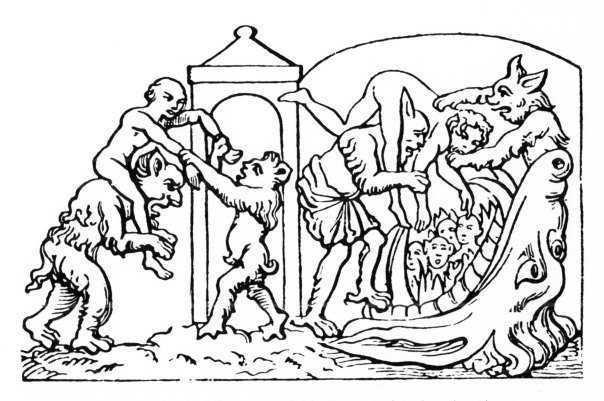

10. Condemned souls of sinners are carried by Demons to their place of punishment.
After a miniature in a Milanese manuscript, fourteenth century.

INTRODUCTION

Throughout history, artists have grappled with the problem of depicting clearly and forcefully the principles of evil and suffering in human existence. Religion, folk beliefs and individual imagination, independently or in fertile combinations, have provided powerful visual realizations of these themes.

Collected in this volume are a wealth of symbols and scenes portraying the appearance, history and activities of the Devil, the embodiment of temptation and vice in the Christian world; his host of demon helpers; the human witches who have placed themselves in his service; the awesome phenomenon of death (according to the Bible, a punishment

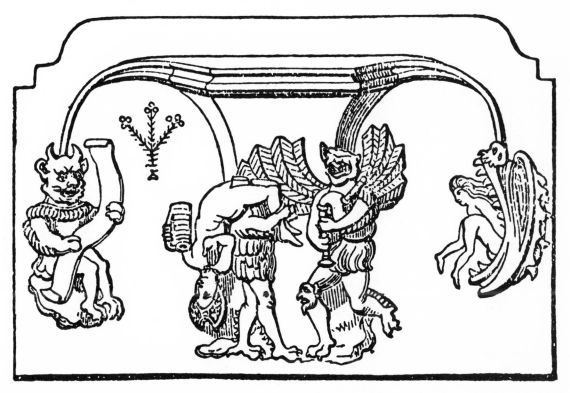

11. English alewives carried by Demons to Hell, in punishment for selling bad ale. After a carved tablet on a miserere seat at Ludlow Church, England, fourteenth century.

for yielding to the Devil's blandishments); the tortures of Hell and the terrors of the Last Judgment.

Centuries of artistic endeavor, particularly in graphics, are represented here. Alongside the ingenious concepts of many little-known and anonymous creators, figure works by Dürer, Holbein, Rembrandt, Cranach, Baldung Grien and other titans.

The concluding chapter, "Religio-Political Devilry," shows how inventively artists at different times in the past have used some of these motifs for their own contemporary purposes of protest or publicity. It is hoped that the scores of bold images in this volume, over and above the esthetic delight they afford, will offer many new suggestions for further work.

E. L.

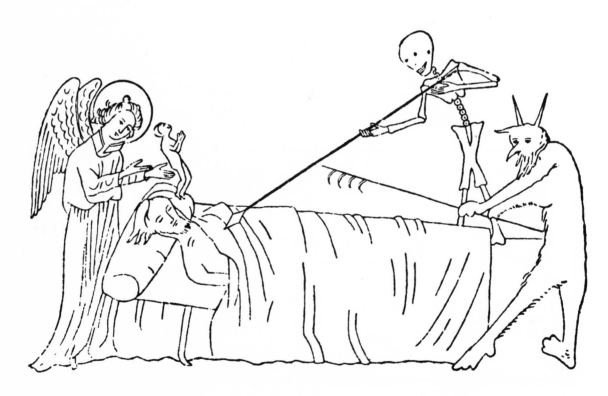

12. Angel and Devil vying for the soul of a dying man. After a miniature in an English manuscript, fourteenth century.

Devils and Demons

Meet the Devil. Nowadays he usually appears as a suave, sly man with telltale horns, hooves and tail; but in the past his bestial nature was emphasized and he cropped up in a wide variety of animal and mixed forms—usually loathly, since (in most artistic conceptions) he had sacrificed his angelic beauty when he disobeyed and rebelled against God. (As shown in some illustrations in this chapter, animal forms for supernatural beings and demons were common in ancient Egyptian and Mesopotamian art.)

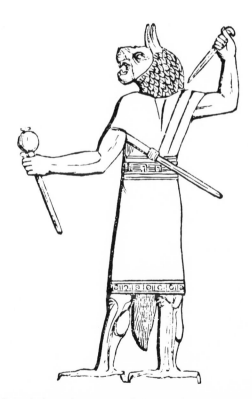

13. The lion-headed, eagle-footed Assyrian-Babylonian demon of disease and evil, holding the mace of wounding and the dagger of killing. After a wall carving at Nineveh.

The Devil's main objective is to tempt man and lead him away from God. Two of the most famous temptations are illustrated in this chapter: the temptation of Jesus in the desert of Palestine and that of St. Anthony in the desert of Egypt. But every human being must be assailed, and the Devil needs many demon helpers, such as Belial and Beelzebub, who go about the world spreading disease and madness (by "possessing" their victims) and instigating all sorts of vice. The vice-ridden may not even be aware that they are playing into the Devil's hands: witness the vain woman who looks into her mirror expecting to see her face and sees—something else.

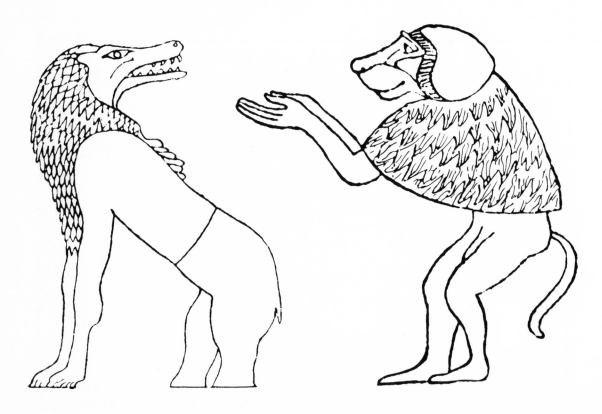

14. Amam (the devourer), demon of the nether world. After an ancient Egyptian papyrus illustration.

15. A Cynocephalus baboon as demon of the nether world. After an illustration in an ancient Egyptian papyrus.

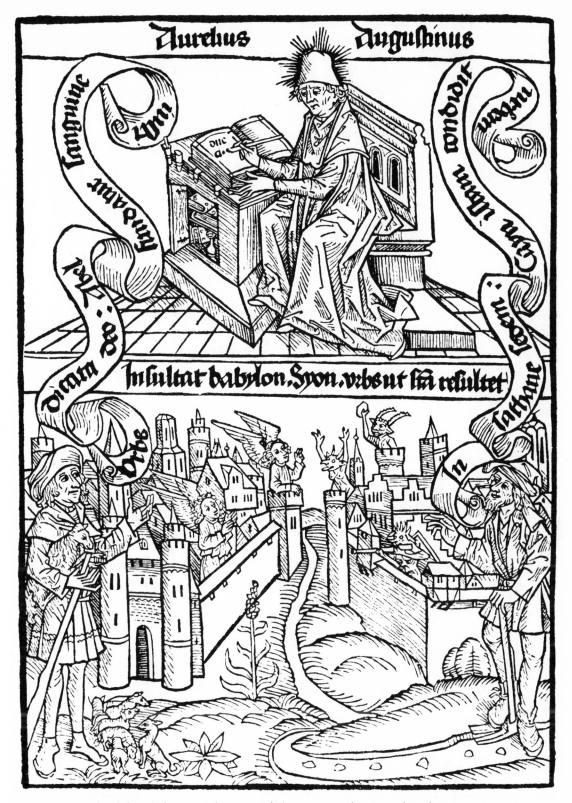

16. The fight of the City of Satan (Babylon) against the City of God (Syon). From Aurelius Augustinus' *De Trinitate*. *De Civitate Dei*, printed by Johann Amerbach, Basle, 1489.

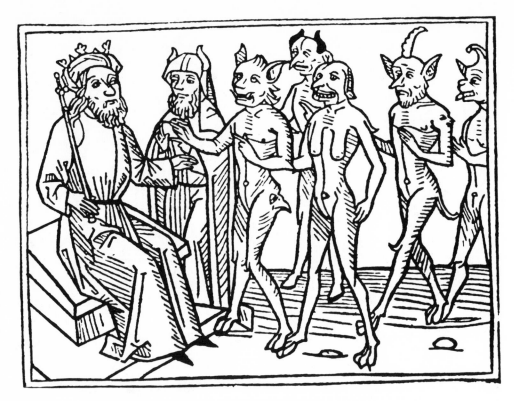

17. The demon Belial appearing with his entourage of four
lesser demons before King Solomon.

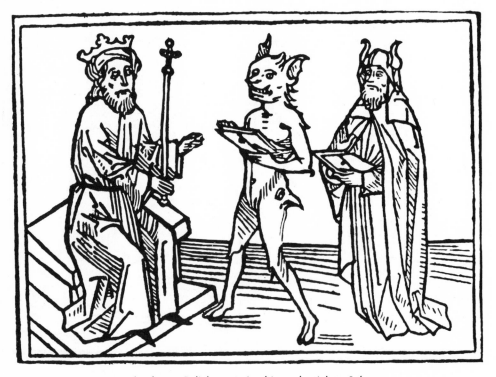

18. The demon Belial presenting his credentials to Solomon.
From Jacobus de Teramo's *Das Buch Belial,* printed at Augsburg, 1473.

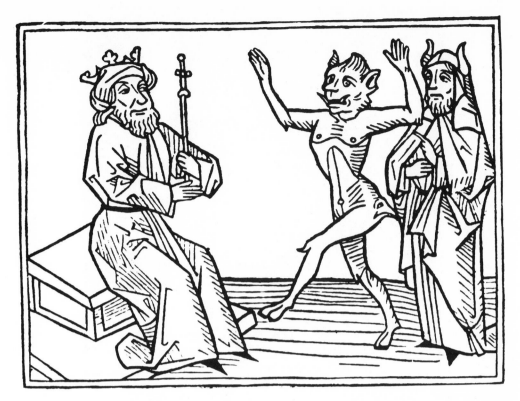

19. The demon Belial dancing before King Solomon.

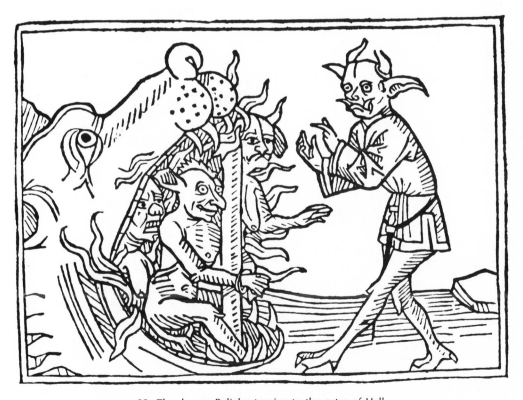

20. The demon Belial returning to the gates of Hell.
From Jacobus de Teramo's *Das Buch Belial*, printed at Augsburg, 1473.

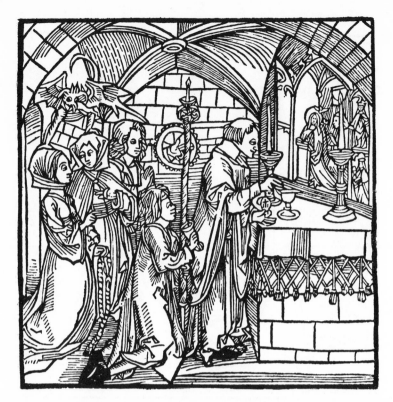

21. Demon causing women to gossip during Mass.

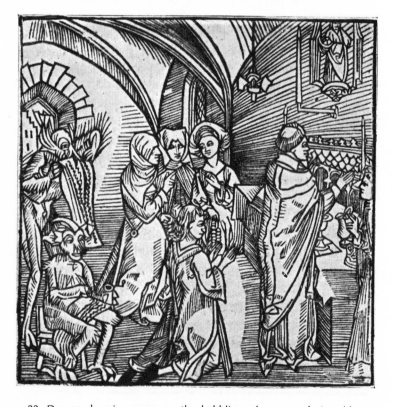

22. Demons keeping score on the babbling of women during Mass.
From Geoffroy de Latour Landry's *Ritter vom Turn*, printed by Michael Furter, Basle, 1493.

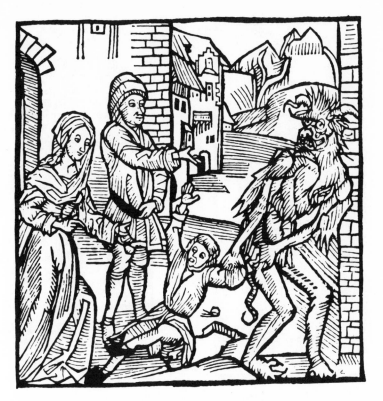

23. Demon carrying off a child promised to the Devil.

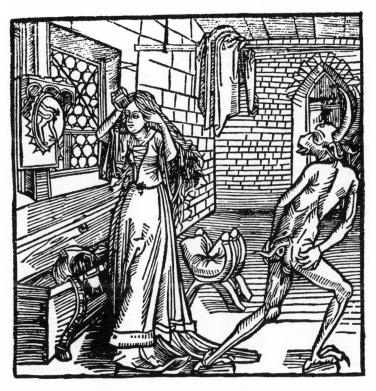

24. The Demon of Vanity and the coquette.
From Geoffroy de Latour Landry's *Ritter vom Turn*, printed by Michael Furter, Basle, 1493.

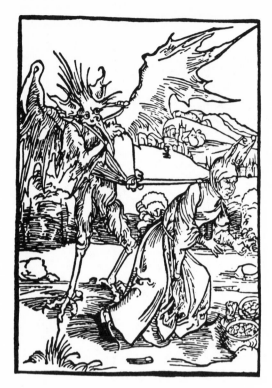

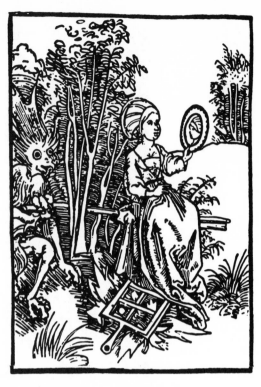

25. The Demon of Greed and the treasure-hunting fool.

26. The Demon of Pride and the conceited woman.

From Sebastian Brant's *Navis Stultifera* (Ship of Fools), printed by Bergman de Olpe, Basle, 1494; attributed to Albrecht Dürer.

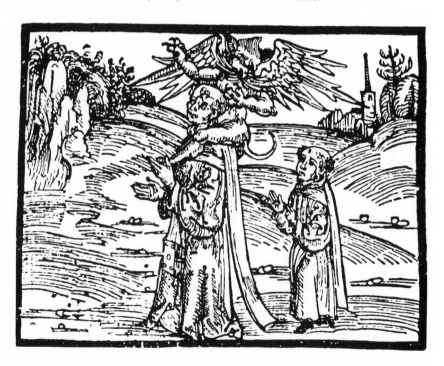

27. The author tempted by the Devil, from Johannes Lichtenberger's *Prognosticatio*, printed by Bartholomaeus Kistler, Strassburg, 1500.

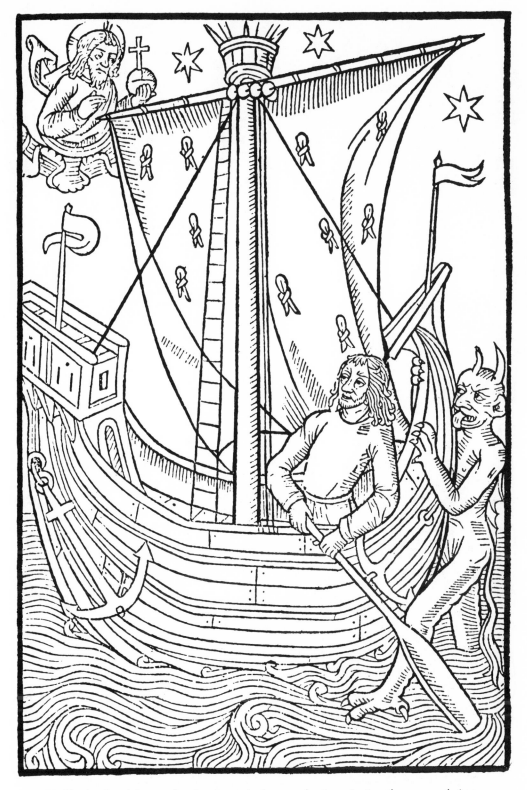

28. The Lord and Satan vying for the soul of man, who is navigating the ocean of vices and sin. From *Le grant kalendrier et compost des Bergiers,* printed by Nicolas Le Rouge, Troyes, 1496.

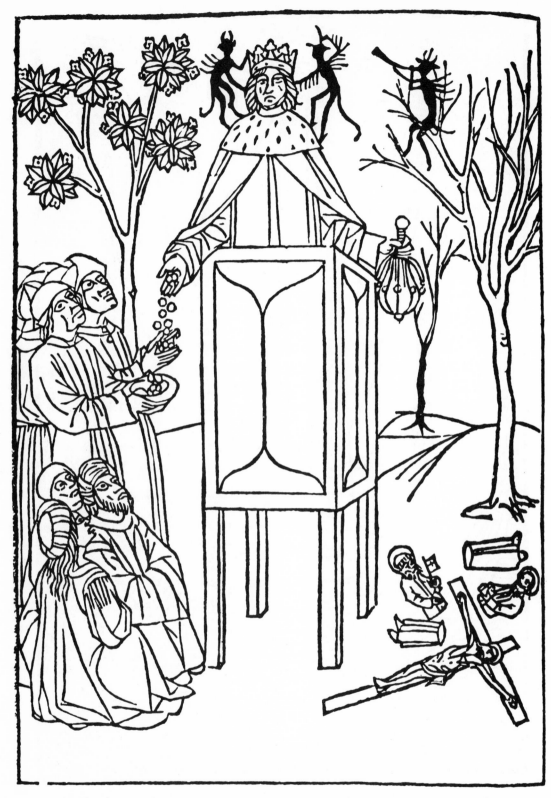

29. The demons of Antichrist, from *La vie de l'Antechrist,* showing the seducing of men by bribe and the destruction of sacred images. Printed at Lyons, late fifteenth century.

30. The Temptation of St. Anthony. After a design by Lucas Cranach the Elder, 1506.

31. Angels defending the Citadel of Heaven against the hordes of the Devil. From Celifodina's *Scripturae Thesaurus*, printed by B. M. Lantzberg, Leipzig, 1510.

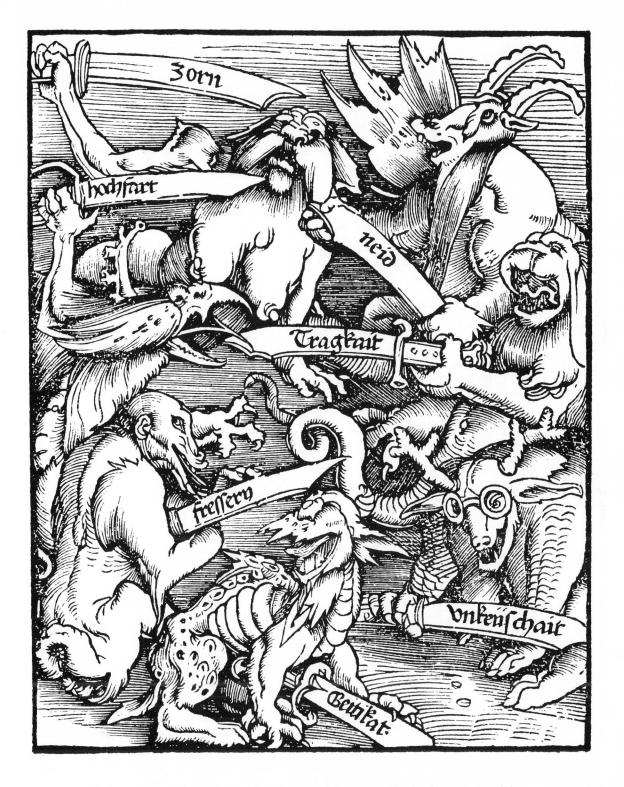

32. Grotesque representation of the demons of the Seven Deadly Sins. Designed by Hans Baldung Grien, from the *Buch Granatapfel*, 1511.

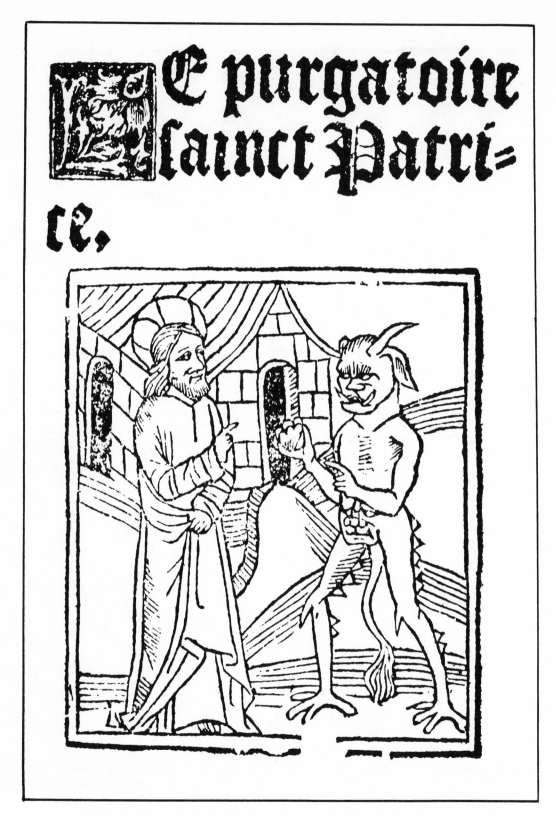

33. The Devil tempting St. Patrick. From *Le purgatoire Sainct Patrice,* Paris, 1530.

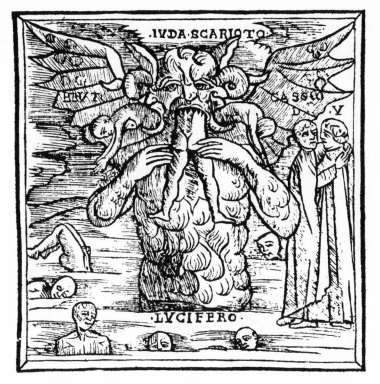

34. Lucifer with a triple face devouring Judas and two other sufferers. From *Opere del poeta Danthe,* printed by Bernardino Stagnino, Venice, 1512.

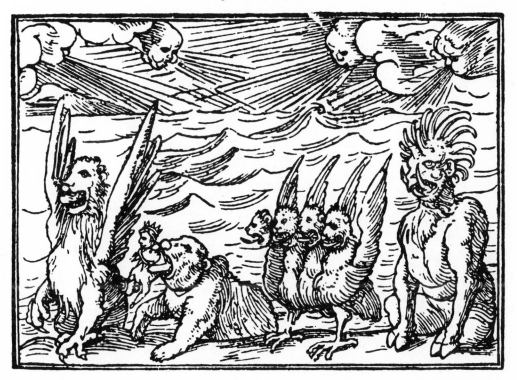

35. Demons, designed by Hans Holbein the Younger, from *Historiarum Veteris Testamenti icones,* printed by Johan and Franciscus Frellon, Lyons, 1543.

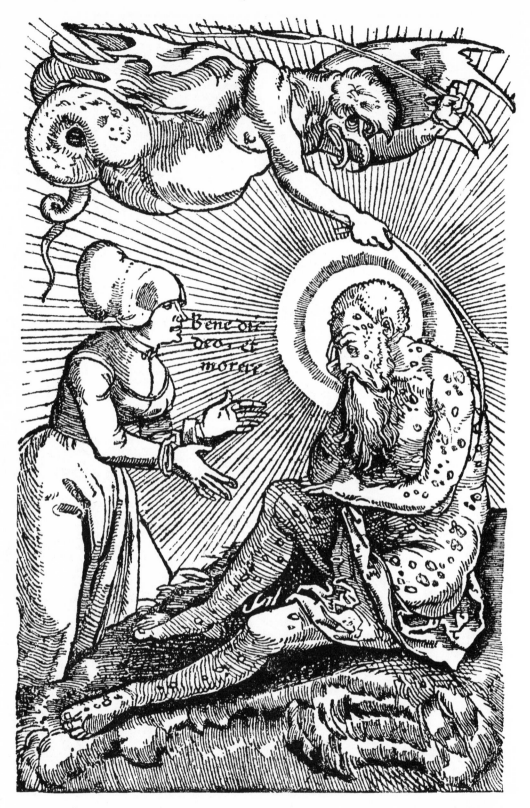

36. Allegoric representation of the Demon of the Plague. From H. von Gersdorf's *Feldtbuch der Wundarzney,* printed by Johann Schott, Strassburg, 1540.

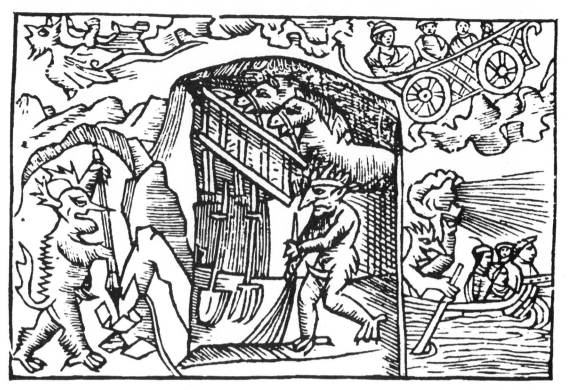

37. Lower demons carrying out minor chores for their human masters.

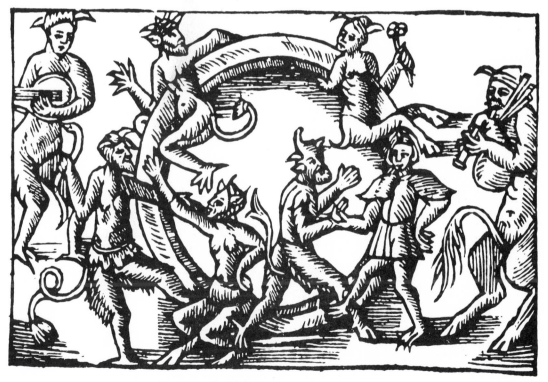

38. Minor devils, demons, satyrs and hobgoblins.
From Olaus Magnus' *Historia de gentibus septentrionalibus*, Rome, 1555.

39. Demon leaving the body of a possessed woman.

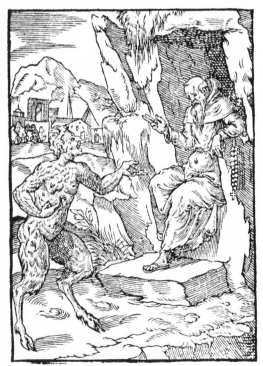

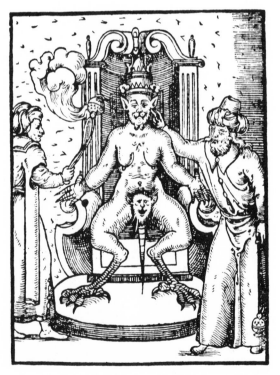

40. The Devil tempting St. Jerome. 41. Witch and warlock attending on Satan.

From Pierre Boaistuau's *Histoires prodigieuses*, Paris, 1597.

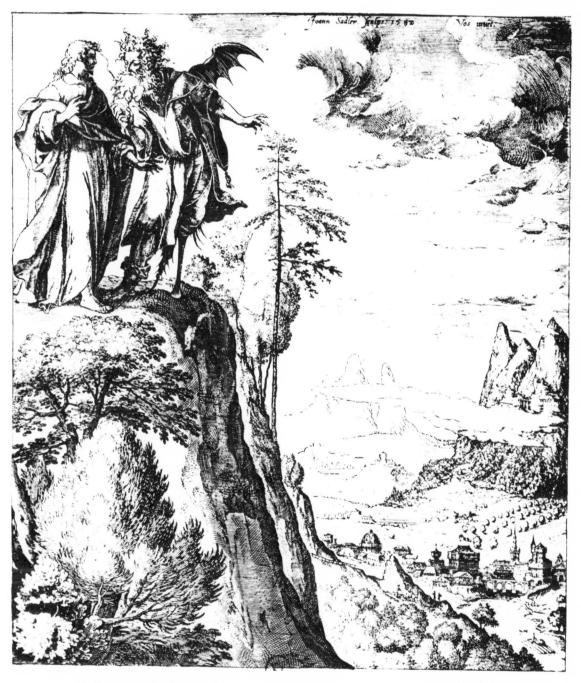

42. Satan tempting Jesus (Luke, 4:5–7). After an engraving by Johann Sadler, Paris, 1582.

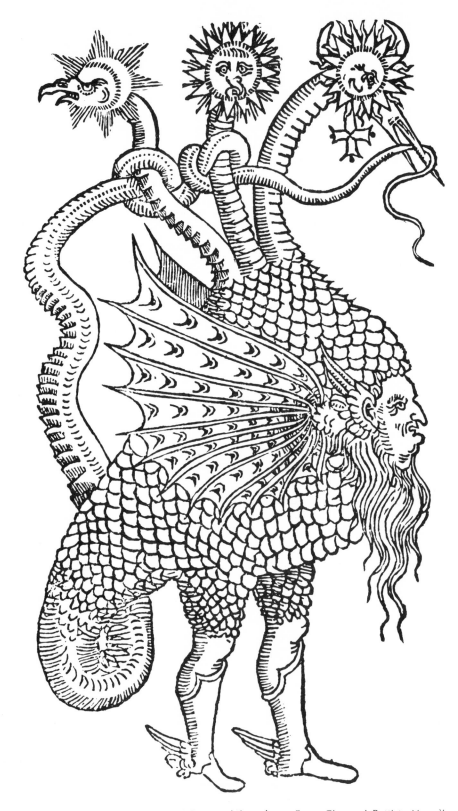

43. The Mercurial demon of the alchemic philosophers. From Giovanni Battista Nazari's
Della transmutatione metallica, Brescia, 1589.

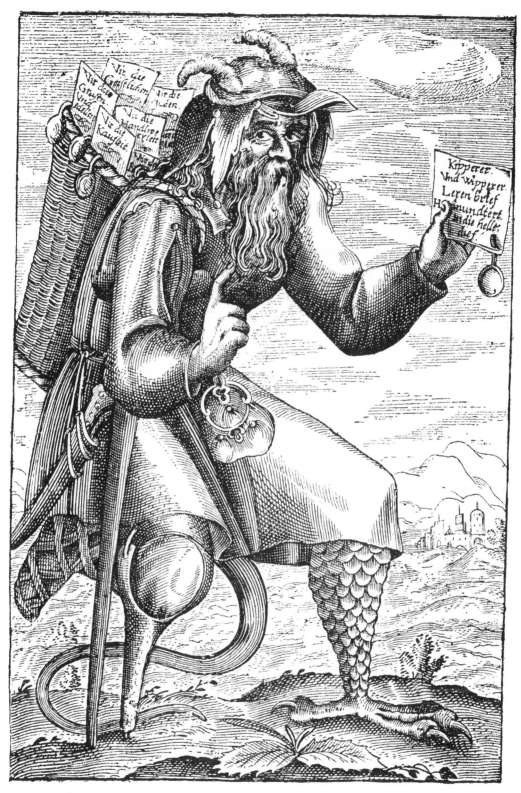

44. The Demon of Counterfeit. From a German handbill against the *Kipperer und Wipperer* (coiners and distributors of inferior coins), Munich, 1620.

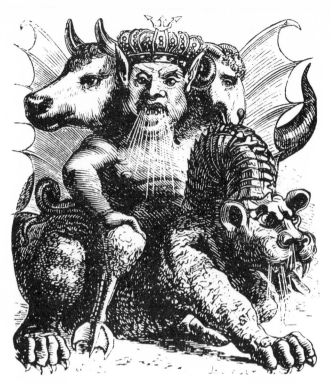

45. Asmodeus, the Biblical demon of anger and lust (Tobit, 3:8).

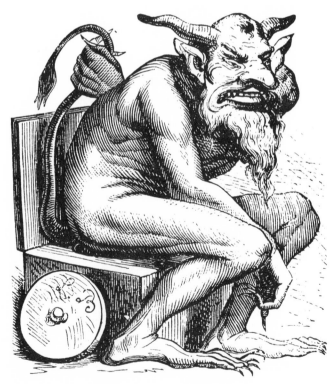

46. Belphegor, the Biblical demon of evil, worshipped by the Moabites (Numbers 25:3).
By L. Breton, in Collin de Plancy's *Dictionnaire infernal*, Paris, 1863.

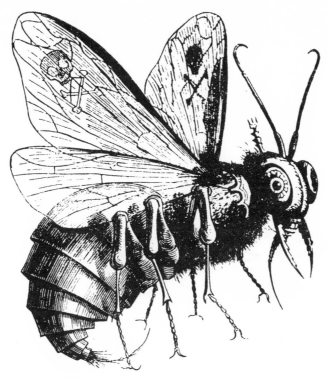

47. Beelzebub, the Biblical demon prince, Lord of the Flies (Matthew 12:24).

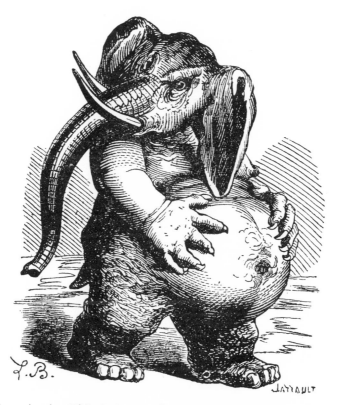

48. Behemoth, the Biblical demon of animal strength (Job 40:15–24).
By L. Breton, in Collin de Plancy's *Dictionnaire infernal*, Paris, 1863.

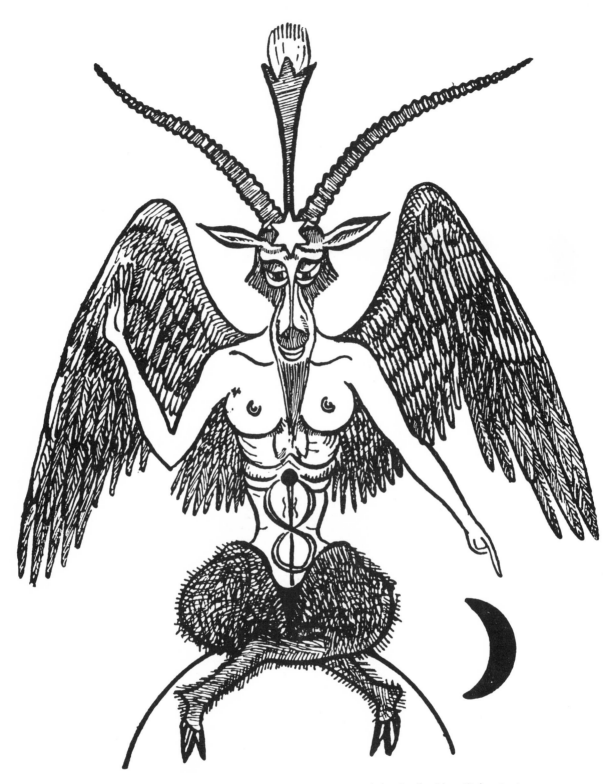

49. *Bouc de la goétie Basphomet,* the goat incarnation of the Devil. After Eliphas Levi, from a pen drawing in a French occult manuscript *La Magie Noire* (Black Magic), nineteenth century.

Casus Luciferi

This is the Fall of Lucifer (the Lightbringer), chief of the rebellious angels. The battle in Heaven, with St. Michael leading the loyal forces against the future Devil (Satan) and demons, is alluded to in the Revelation of St. John the Divine, and has captured the imagination of many creative men. In literature its fullest elaboration is found in Milton's *Paradise Lost*. In art it has inspired innumerable works, including Dürer's *Apocalypse* woodcuts.

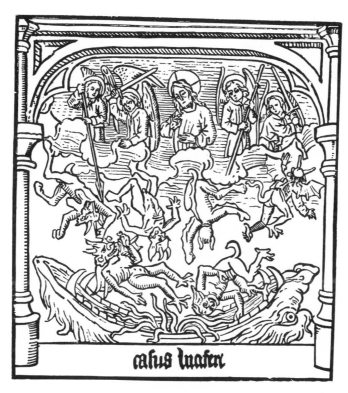

50. *Casus Luciferi* (the fall of Lucifer). From *Biblia Pauperum* (the poor man's Bible), a block-book printed at Bamberg, 1470.

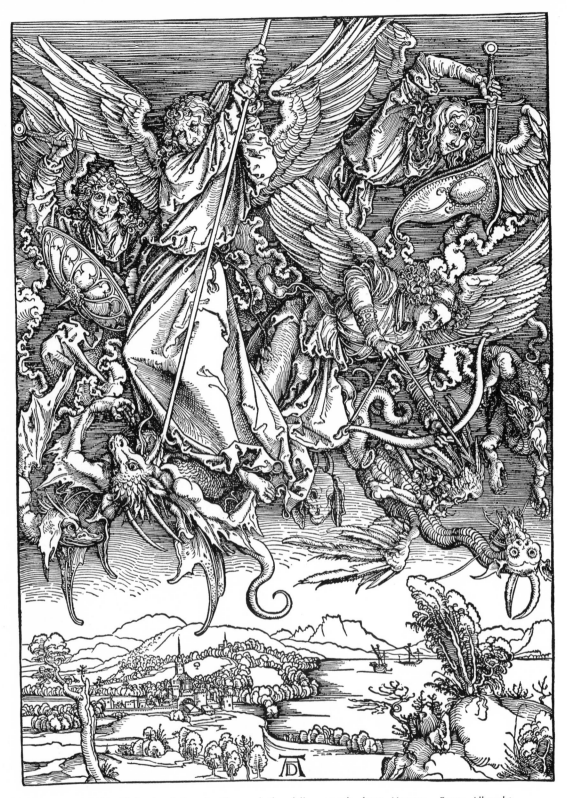

51. St. Michael evicting Lucifer and the fallen angels from Heaven. From Albrecht Dürer's *Apocalypse*, Nuremberg, 1498.

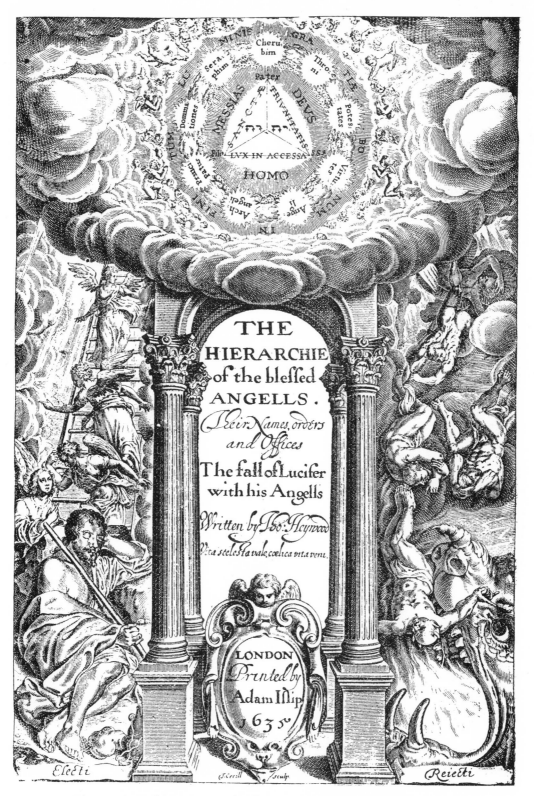

52. Title page from Thomas Heywood's *The Hierarchie of the blessed Angells,* engraved
by T. Cecill, printed by Adam Islip, London, 1635.

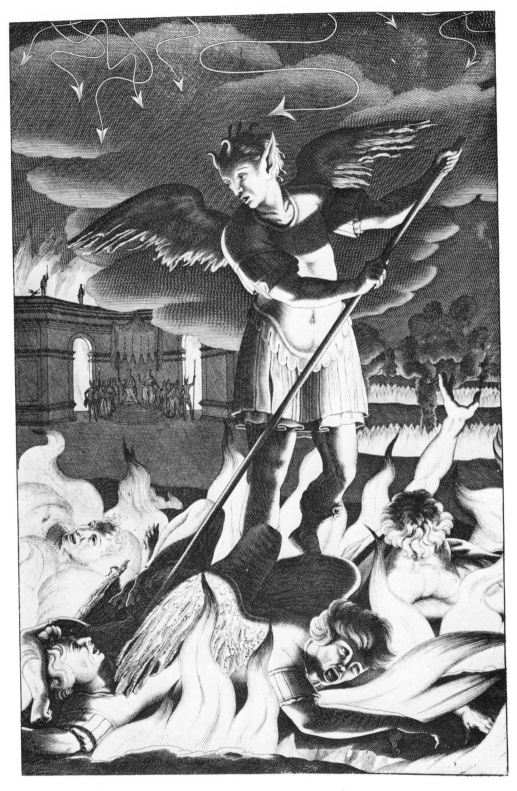

53. Lucifer beginning to reign over the souls of sinners. Illustration by John Baptist
Medina for John Milton's *Paradise Lost*, London, 1688.

Faust and Mephistopheles

In some versions of medieval demon lore, Mephistopheles was second only to Lucifer among the fallen archangels. In the Faust story, a German Renaissance folk legend which gained literary prominence with Marlowe and Goethe, Mephistopheles is the devil who is summoned by the aged scholar-magician Faust and heaps all pleasures on him in return for his soul.

It was Goethe's *Faust* especially which inspired an incredible number of literary, theatrical and musical adaptations, as well as a host of illustrations, including those by Delacroix shown in this chapter. It was the figure of Faust as a scholar thirsting for knowledge which inspired the unforgettable etching by Rembrandt.

54. *Méphistophélès,* the popular sophisticated devil. From a pen drawing in a French occult manuscript, *La Magie Noire,* Paris, nineteenth century.

HISTORIA

Von D. Johañ

Fausten/ dem weitbeschreyten Zauberer vnd Schwartzkünstler/

Wie er sich gegen dem Teuffel auff eine be-
nandte zeit verschrieben/ Was er hierzwischen für
seltzame Abenthewr gesehen/ selbs angerich-
tet vnd getrieben/ biß er endlich sei-
nen wol verdienten Lohn
empfangen.

Mehrertheils auß seinen eygenen

hinderlassenen Schrifften/ allen hochtragen-
den/ fürwitzigen vnnd Gottlosen Menschen zum schreckli-
chen Benspiel/ abschewlichem Exempel/ vnnd trew-
hertziger Warnung zusammen gezo-
gen/ vnd in Druck ver-
fertiget.

IACOBI IIII.

Seyt Gott vnderthänig widerstehet dem
Teuffel/ so fleuhet er von euch.

CVM GRATIA ET PRIVILEGIO.

Gedruckt zu Franckfurt am Mayn/ durch Johann Spies.

M. D. LXXXVII.

55. Title page from the oldest extant book about Dr. Johannes Faust, *History of Dr. Johannes Faust, the Notorious Sorcerer and Master of Black Magic*, printed by Johann Spies, Frankfurt, 1587.

The Tragicall Hiſtorie of the Life and Death of Doctor Fauſtus.

With new Additions.

Written by CH. MAR.

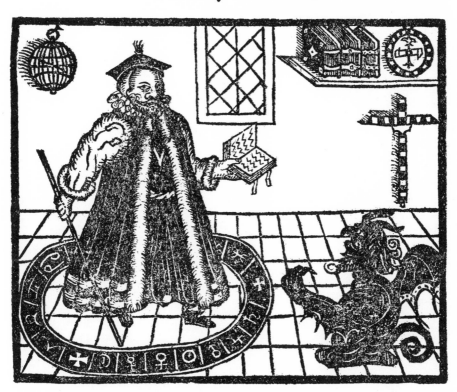

Printed at London for *Iohn Wright*, and are to be ſold at his
ſhop without Newgate. 1631.

56. Title page from the oldest extant English chapbook edition of Christopher Marlowe's *The Tragicall Historie of the Life and Death of Doctor Faustus,* published by John Wright, London, 1631.

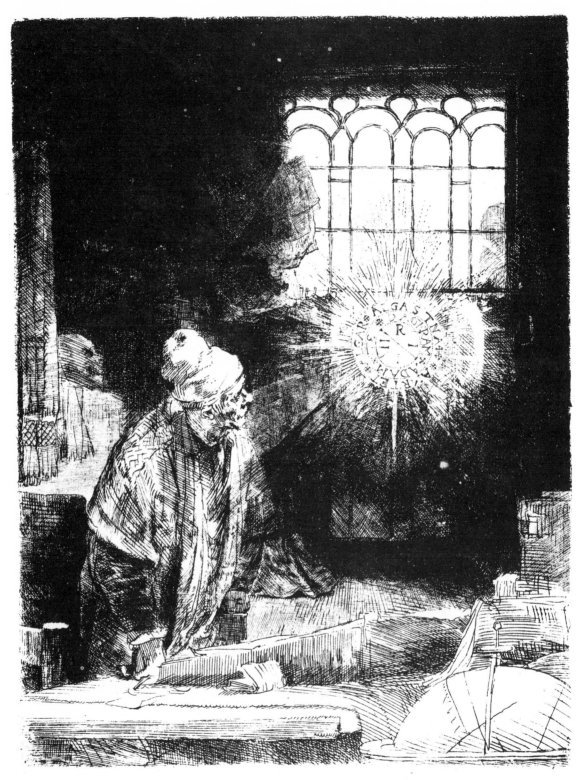

57. Dr. Johann Faust watching a magic disc in his study. Engraving by Rembrandt
Harmensz van Rijn, 1652.

Heute Freytag/den 18. May.
Werden die
Sächsischen Hoch = Teutschen
COMOEDIANTEN
Auff ihren Schau=Platz das unvergleichliche und Welt=
bekandte Stück präsentiren/ genandt :
Das Leben und Todt des grossen
Ertz=Zauberers/
D. JOHANNES FAUSTUS
Mit Vortrefflicher Pickelhärings Lustigkeit von
Anfang biß zum Ende.

In dieser Haupt=Action wird mit Verwunderung zu sehen seyn :

1. Pluto auf einen Trachen in der Lufft schwebende.
2. Doct. Faustus Zauberey und Beschwerung der Geister.
3. Pickelhäring/ in dem er Gold samlen will/ wird von allerhand bezauberten Vö=geln in der Lufft vexiret.
4. Doct. Faustus Panquet/ bey welchen die Schau Eßen in wunderliche Fi=guren verwandelt werden.
5. Seltzam wird zu sehen seyn/ wie aus einer Pastete Menschen/ Hunde/ Katzen und andere Thiere hervor kommen und durch die Lufft flügen.
6. Ein Feuerspeyende Rabe kömbt durch die Lufft geflogen/ und kündiget Fau=sten den Todt an.
7. Endlich/ wird Faustus von den Geistern weg geholet.
8. Zuletzt wird die Hölle mit schönen Feuerwercken außgezieret/ präsentiret werden.

Zum Beschluß sol denen Hochgeneigten Liebhabern/ diese gantze Haupt=Action/ durch einen Italiänischen Schatten präsentiret werden/ welches vortrefflich Rar/ und versichert das Geld doppelt werth ist/ worbey auch eine Masque=rade von 6. Persohnen/ nemlich ein Spanier/ zwey Gaudiebe/ ein Schul=meister/ ein Bauer und Bäuerin/ welche alle ihren absonderlichen Tantz haben/ und sehr lächerlich wird anzusehen seyn.

Nach diesen sol zum Nach=Spiel agiret werden/ die vortreffliche und lu=stige Action aus den Frantzösischen ins Teutsche übersetzet/ genandt:
Der von seiner Frauen wohl vexirte Ehemann/
George Dandin.

Und weil es Heute ohnfehlbar zum letzten mahl ist/ sol auff den hintersten Platz nicht mehr als 8. Grot genommen werden/ welches zur Nachricht.

Der Schau=Platz ist in Sehl. Capitain Nissen Hause/ auff der Langen Strasse vor der Natel. Wird præcise umb 3. Uhr angefangen.

Einer sage es dem andern.

58. Playbill for the oldest German Faust comedy, *The Life and Death of the Great Arch-Sorcerer Dr. Johannes Faustus,* Bremen, 1688.

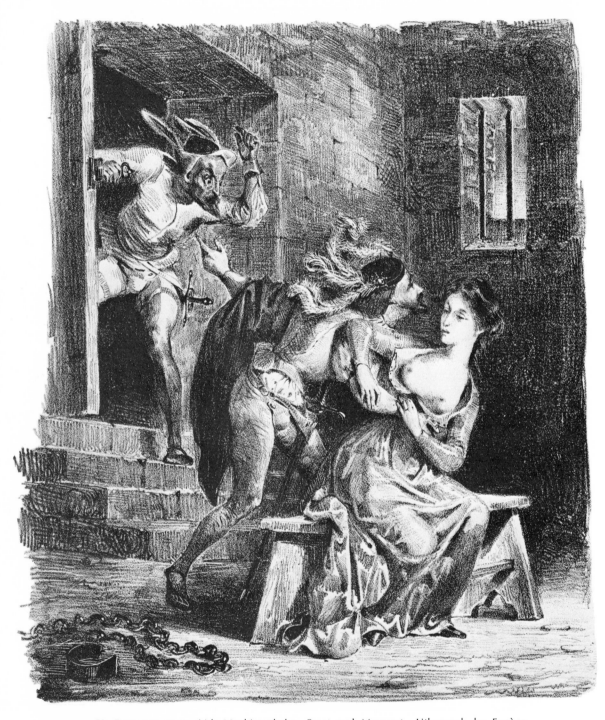

59. Dungeon scene with Mephistopheles, Faust and Margaret. Lithograph by Eugène Delacroix for Johann Wolfgang von Goethe's *Faust,* printed by Goyer & Hermet, Paris, 1828.

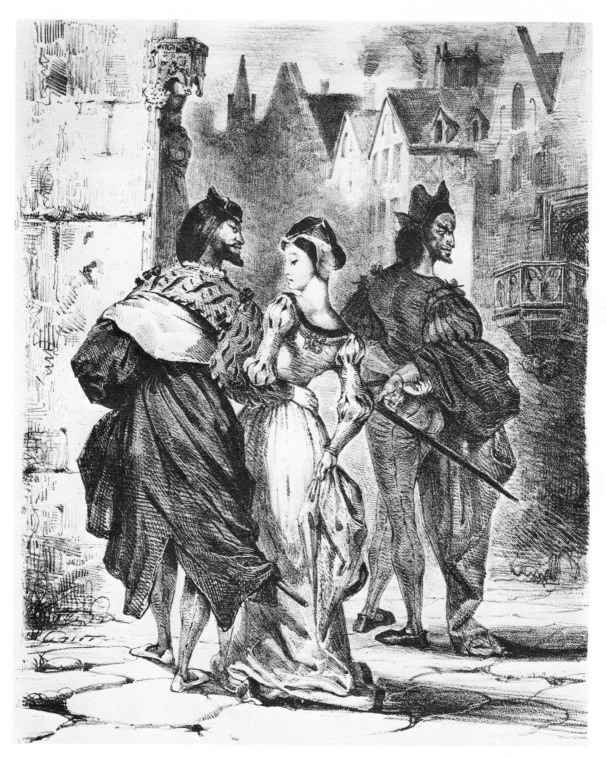

60. Garden scene with Mephistopheles, Faust, and Margaret. Lithograph by Eugène Delacroix for Johann Wolfgang von Goethe's *Faust*, printed by Goyer & Hermet, Paris, 1828.

61. Prototype of the nineteenth-century romantic devil. From *The Devil Walk* by
Thomas Landseer, London, 1831.

Hell and Damnation

In Christian belief, Hell is the place where sinners are punished after death. Dante's *Inferno* contains the most vivid descriptions of the sufferings inflicted on the damned by the demons of Hell. Similar places of punishment in the afterlife form part of other religious beliefs, especially popular Buddhism in the Far East. Two illustrations in this chapter show a scene of judging of souls in ancient Egyptian religion and a modern depiction of the punishments in Hades of three arch-sinners of ancient Greek mythology: Tantalus was never allowed to taste of the fruit and water that were so near to him; Sisyphus had constantly to roll a huge rock to the top of a hill, from which it would just as constantly roll back; Ixion was fastened to a perpetually turning wheel.

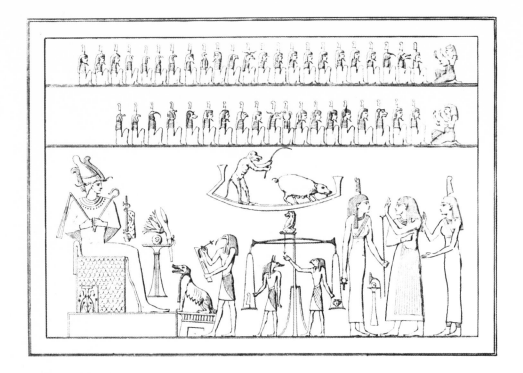

62. Judgment of souls before the nether-world court of Osiris. After an ancient Egyptian papyrus illustration.

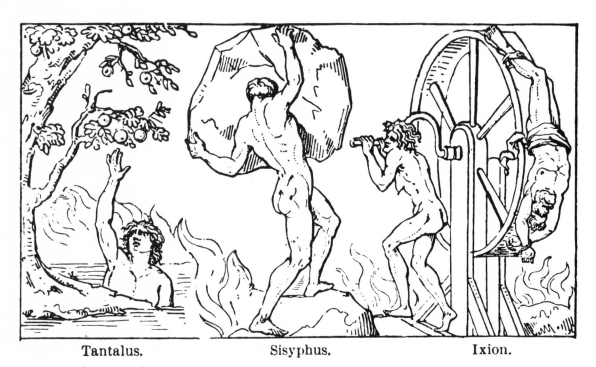

Tantalus. Sisyphus. Ixion.

63. The punishment of Tantalus, Sisyphus and Ixion in Tartarus, the hell of ancient Greek mythology. After an English engraving.

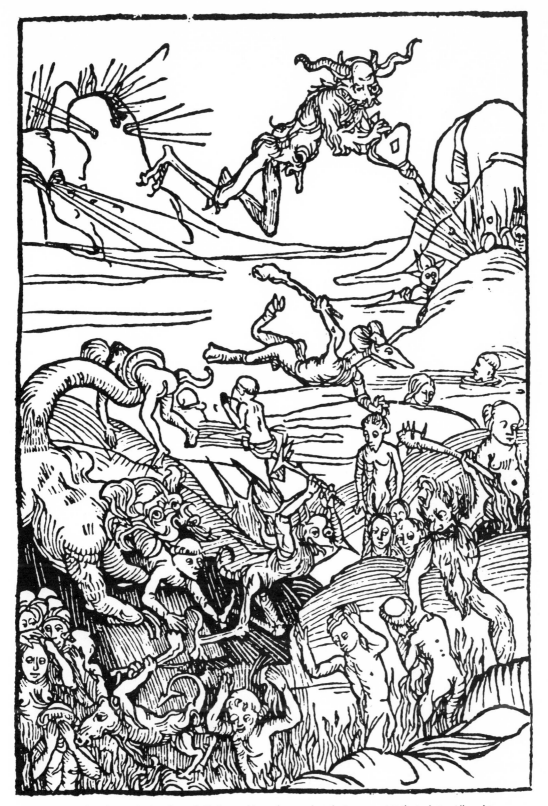

64. The demonic hordes of Hell catching the souls of sinners. Attributed to Albrecht Dürer. From *Warning vor der falschen lieb dieser werlt*, printed by Peter Wagner, Nuremberg, 1495.

INFERNO.

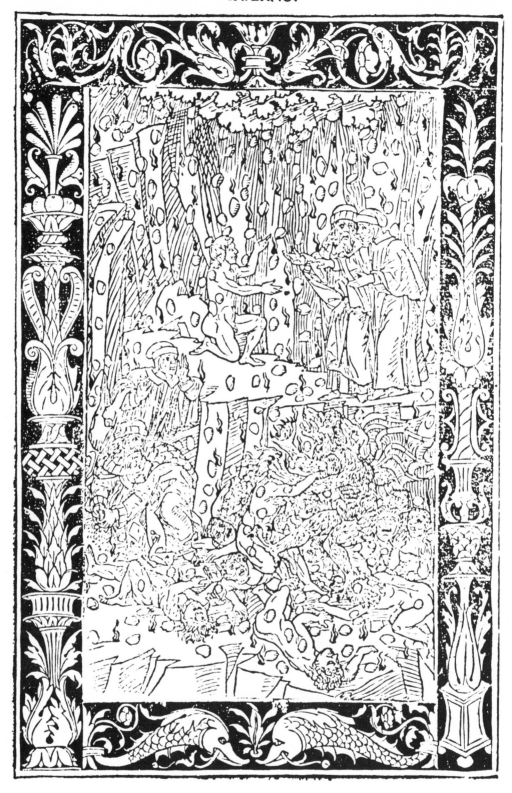

65. Inferno, from Dante Alighieri's *La Divina Commedia,* printed by Boninus de Bonini, Brescia, 1487.

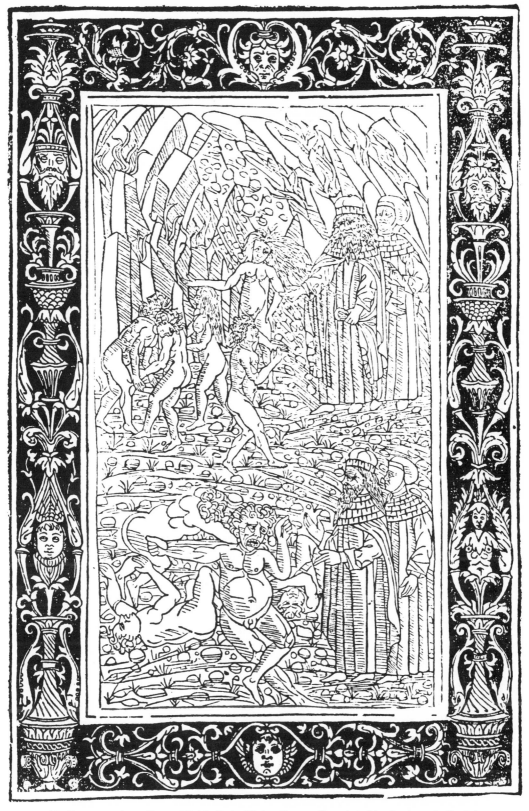

66. Purgatory, from Dante Alighieri's *La Divina Commedia,* printed by Boninus de Bonini, Brescia, 1487.

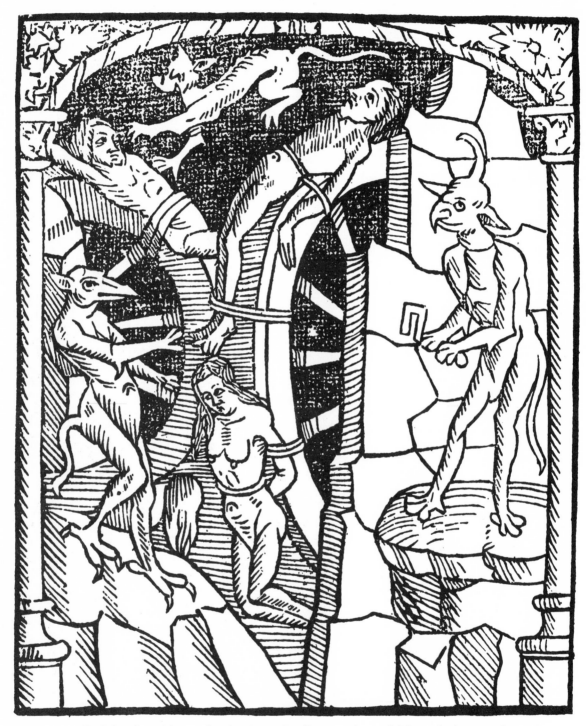

67. Infernal punishment for the Seven Deadly Sins: the prideful are broken on the wheel. From *Le grant kalendrier et compost des Bergiers,* printed by Nicolas Le Rouge, Troyes, 1496.

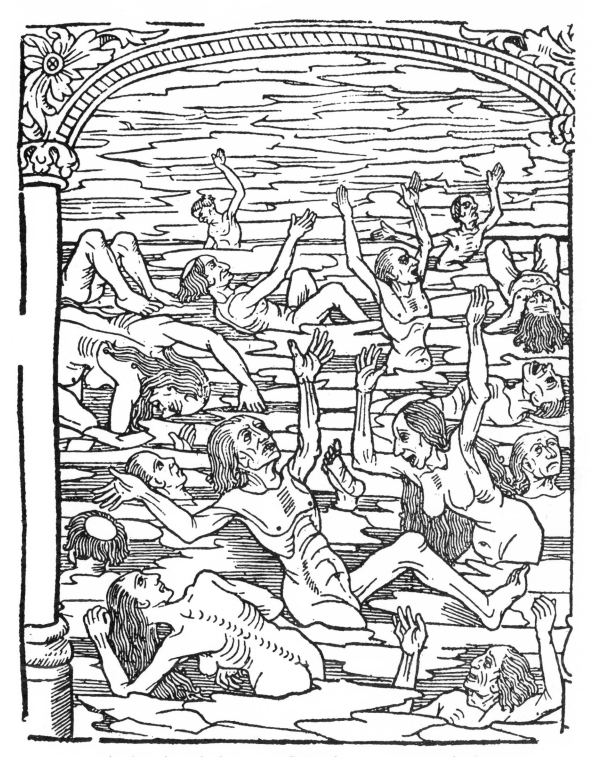

68. Infernal punishment for the Seven Deadly Sins: the envious are immersed in freezing water. From *Le grant kalendrier et compost des Bergiers,* printed by Nicolas Le Rouge, Troyes, 1496.

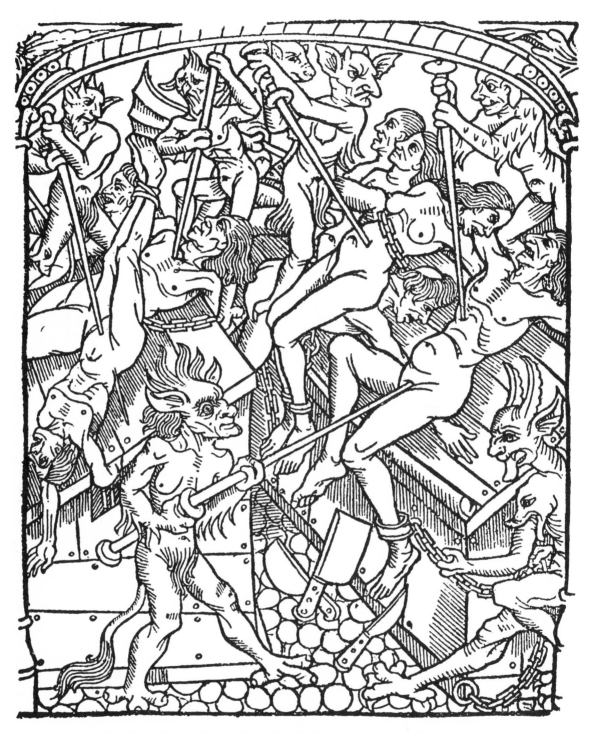

69. Infernal punishment for the Seven Deadly Sins: the angry are dismembered alive.
From *Le grant kalendrier et compost des Bergiers,* printed by Nicolas Le Rouge, Troyes,
1496.

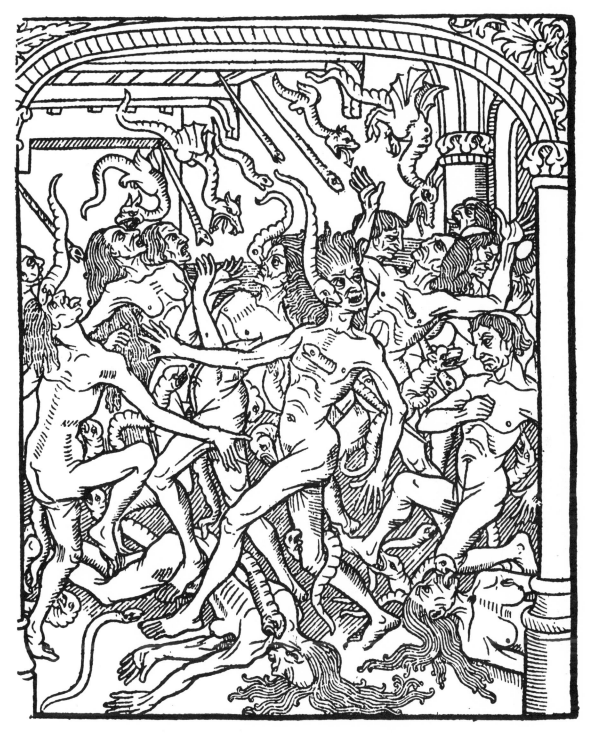

70. Infernal punishment for the Seven Deadly Sins: the slothful are thrown into snake-pits. From *Le grant kalendrier et compost des Bergiers,* printed by Nicolas Le Rouge, Troyes, 1496.

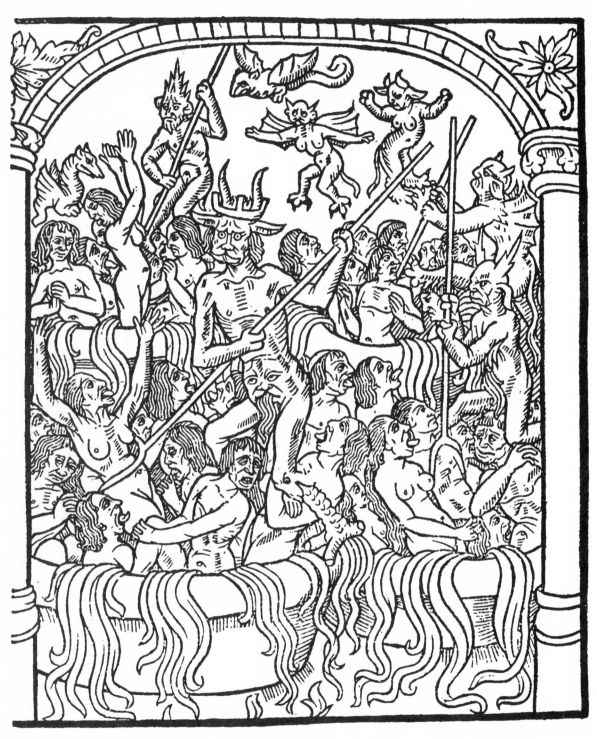

71. Infernal punishment for the Seven Deadly Sins: the greedy are put into cauldrons of boiling oil. From *Le grant kalendrier et compost des Bergiers,* printed by Nicolas Le Rouge, Troyes, 1496.

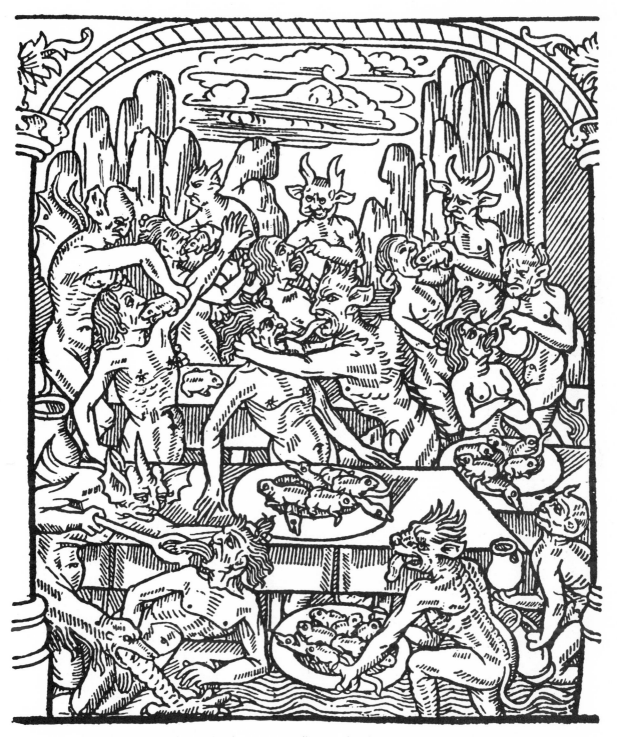

72. Infernal punishment for the Seven Deadly Sins: the gluttonous are forcefed on toads, rats and snakes. From *Le grant kalendrier et compost des Bergiers,* printed by Nicolas Lê Rouge, Troyes, 1496.

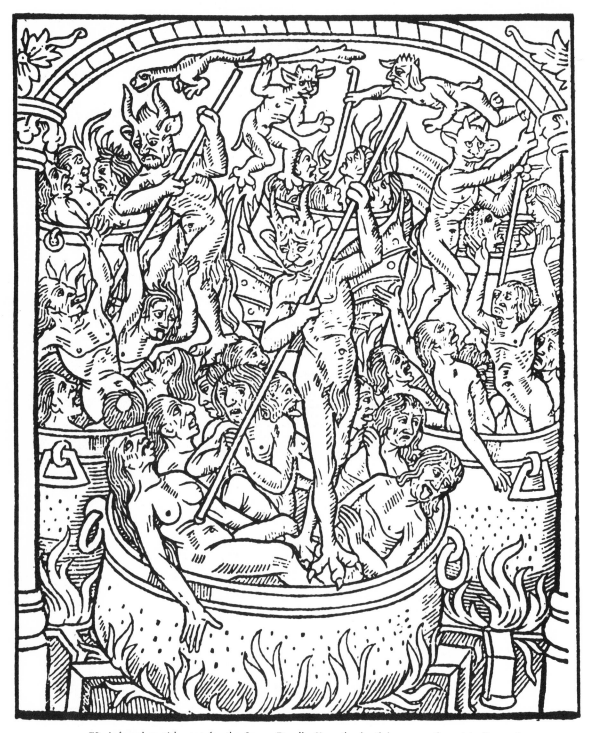

73. Infernal punishment for the Seven Deadly Sins: the lustful are smothered in fire and brimstone. From *Le grant kalendrier et compost des Bergiers*, printed by Nicolas Le Rouge, Troyes, 1496.

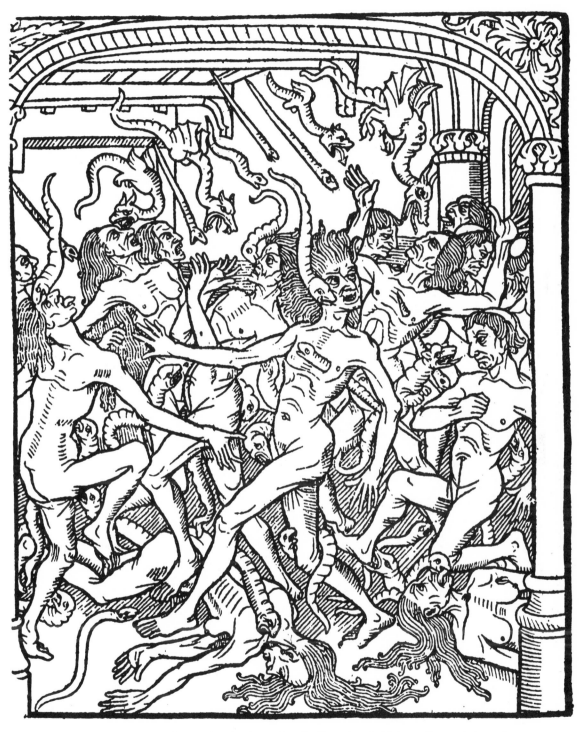

70. Infernal punishment for the Seven Deadly Sins: the slothful are thrown into snake-pits. From *Le grant kalendrier et compost des Bergiers,* printed by Nicolas Le Rouge, Troyes, 1496.

71. Infernal punishment for the Seven Deadly Sins: the greedy are put into cauldrons of boiling oil. From *Le grant kalendrier et compost des Bergiers,* printed by Nicolas Le Rouge, Troyes, 1496.

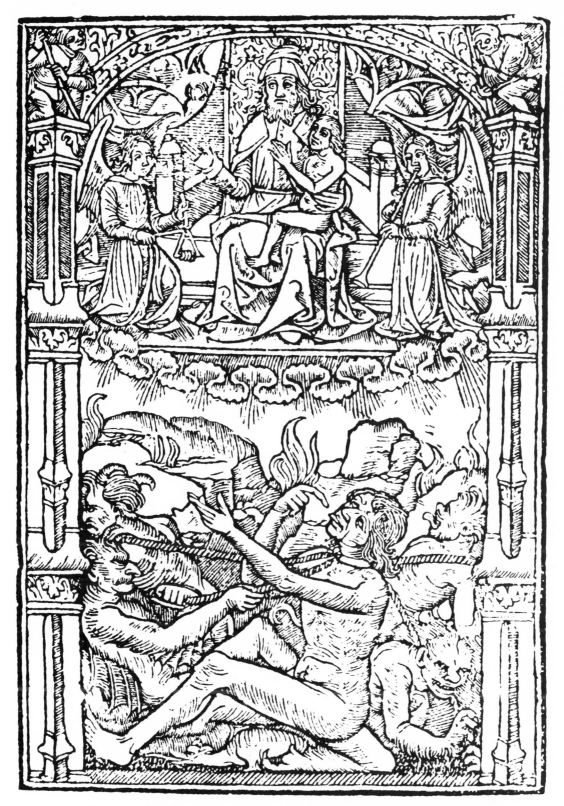

74. Dives in Hell and Lazarus in Heaven. From Jacob Sprenger and H. Institor's *Malleus Maleficarum* (The Hammer of Witches), printed by Jean Patit, Paris, 1510.

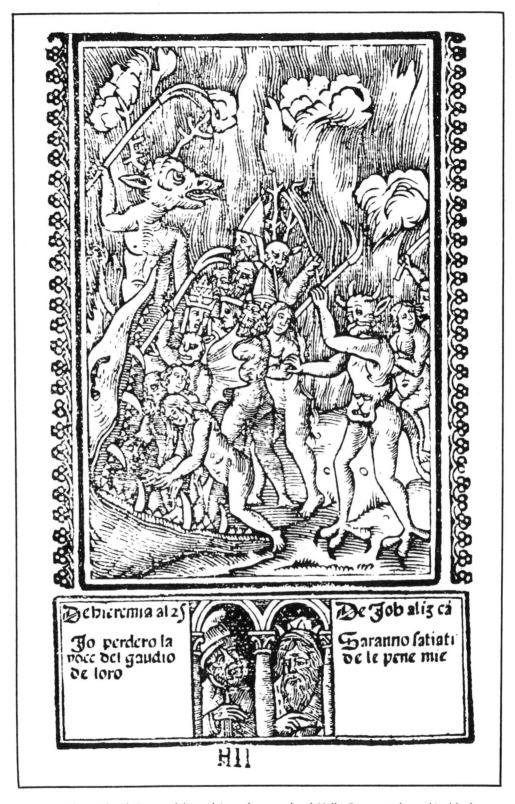

75. The souls of sinners delivered into the mouth of Hell. From a xylographic block-book, *Opera*, engraved and printed by Giovanni Andrea Vavassore, Venice, 1510.

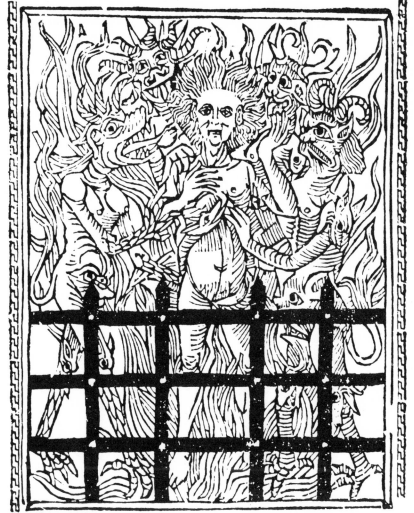

The parlyament of deuylles.

S Mary was grette with Gabryell
And had concepued and borne a chylde
All þ deuylles of the erthe of þ ayre & of hell
Helde theyr parlyament of þ mayde mylde
C what man had mad her wombe to swel
C To tempt her ye tende to sylde
Her chyldes fader who can tell
who dyde with her tho werkes wylde

76. Infernal demons. From *The parlyament of deuylles*, printed by Richard Faques, London, 1521.

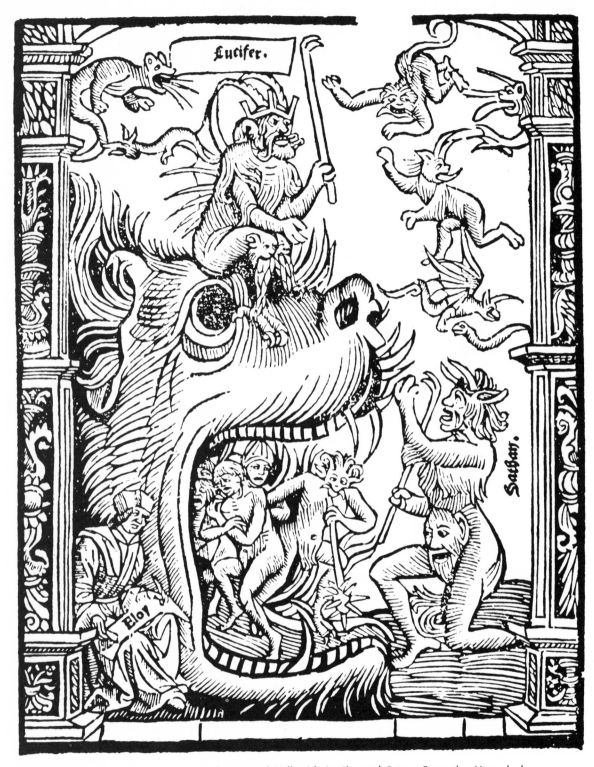

77. Title page showing the jaws of Hell with Lucifer and Satan. From the *Livre de la Deablerie*, printed by Michel Le Noir, Paris, 1568.

The Apocalyptic Horsemen

Among the visions granted to St. John on Patmos, as recorded in Revelations (or the Apocalypse), was that of four maleficent horsemen, the last of whom is there identified as Death (chapter 6, verses 1–8). The others have been identified as Plague, Famine and War, let loose against mankind. The most famous of the many illustrations of the Four Horsemen of the Apocalypse is the one by Dürer.

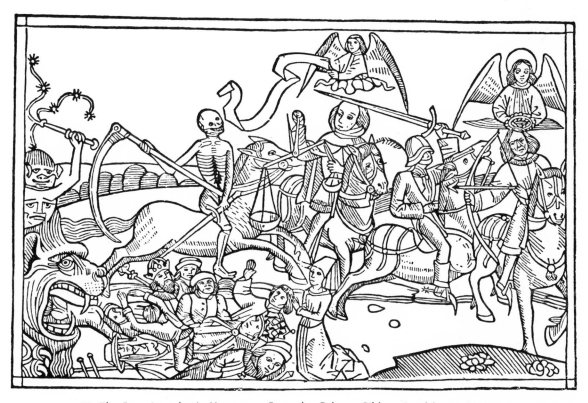

78. The Four Apocalyptic Horsemen. From the Cologne Bible, printed by Bartholomäus von Uncle, 1479.

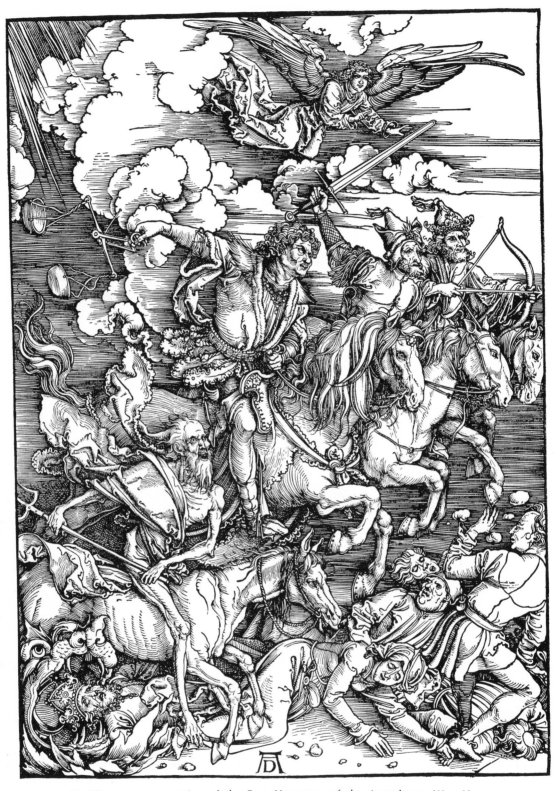

79. Allegoric representation of the Four Horsemen of the Apocalypse: War, Hunger,
Plague and Death. From Albrecht Dürer's *Apocalypse*, Nuremberg, 1498.

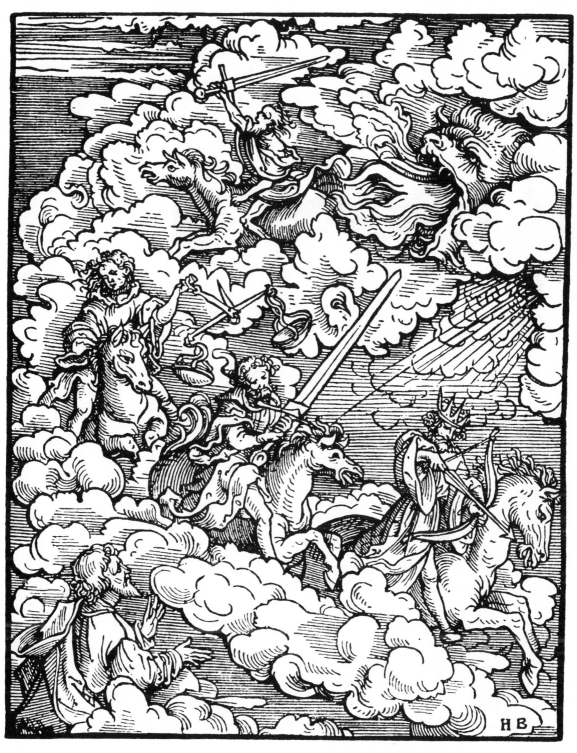

80. The Apocalyptic Horsemen. Woodcut by Hans Burgkmair, from *Das Neue Testament*, printed by Silvan Othmar, Augsburg, 1523.

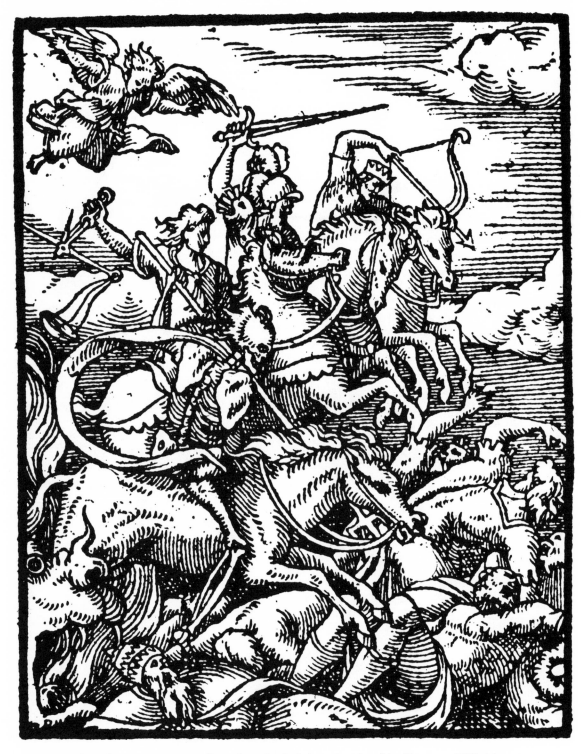

81. The Four Horsemen. From *Apocalypsis S. Joannis,* printed by Hermann Gülfferichen, Frankfurt, 1553.

Witches and Warlocks

The true practicing witches of the late Middle Ages, Renaissance and later periods (as distinguished from mentally ill or asocial people accused of witchcraft) were most likely stubborn adherents of pre-Christian pagan religious beliefs in which the deity or deities (for Christians, the Devil and his demons) partook of animal forms. (The Celtic enchanter Merlin is included in this chapter as an example of a pre-Christian figure who remained alive in Christian memories.)

Witches and warlocks (a special term for male witches) were supposed to be able to prophesy, cast spells, raise storms, change shape, and much more. They were aided by certain animal "familiars," often cats and toads. They assembled periodically at sabbaths, where they worshipped Satan. As shown in some of the sixteenth-century German illustrations in this chapter, female witches were not always thought of as withered crones.

82. The Devil making love to a witch.

83. Demons riding to the Sabbath.
From Ulrich Molitor's *Von den Unholden und Hexen.* Constance, 1489.

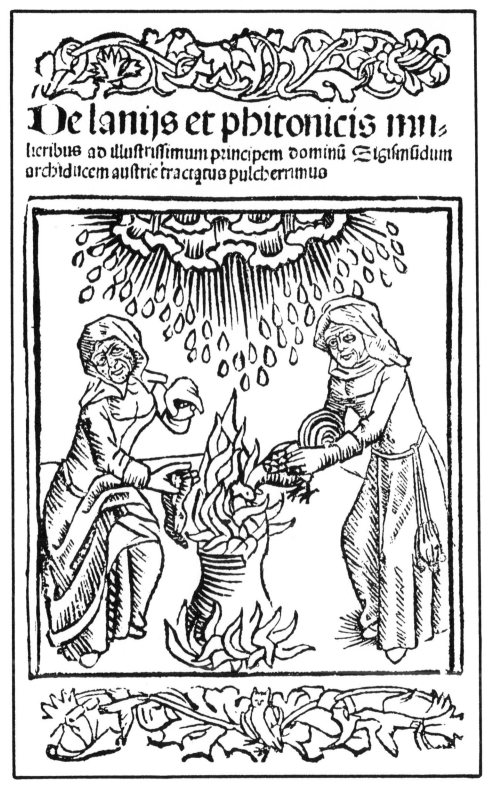

84. Witches brewing up a hailstorm. From the title page of Ulrich Molitor's *De lanijs et phitonicis mulieribus,* printed by Cornelius de Zierikzee, Cologne, 1489.

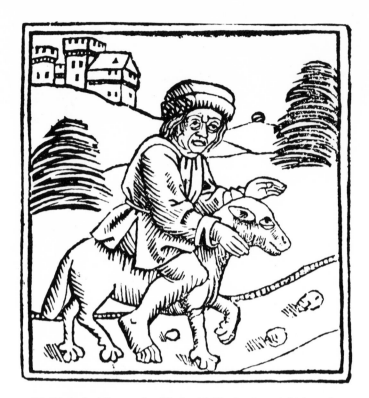

85. Warlock riding to the Witches' Sabbath. From Ulrich Molitor's *De lanijs et phitonicis mulieribus,* printed by Cornelius de Zierikzee, Cologne, 1489.

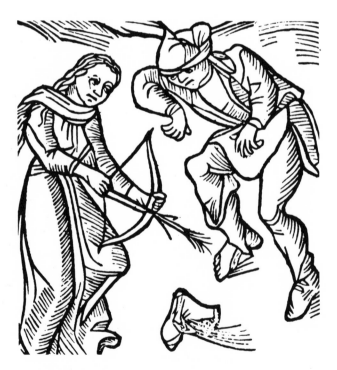

86. Witch "inoculating" a man by shooting a twig through his foot. From Ulrich Molitor's *De lanijs et phitonicis mulieribus,* Cologne, 1489.

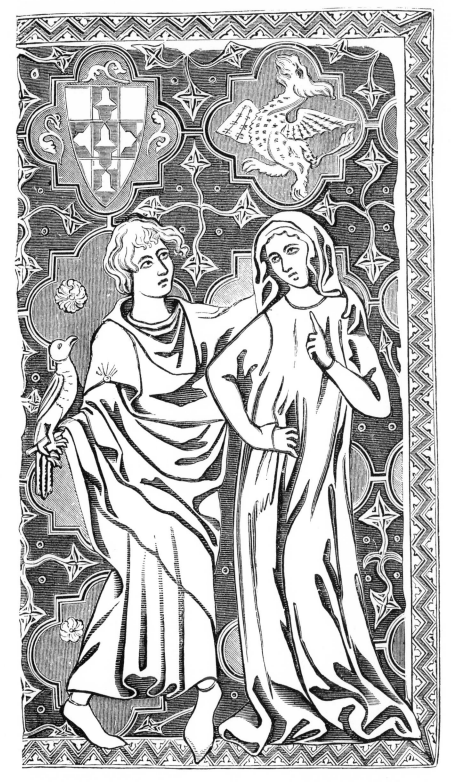

87. The enchanter Merlin, magician of King Arthur's Round Table, meeting the fairy Viviane in the Forest of Broceliande. After an enameled book cover, Limoges, early fifteenth century.

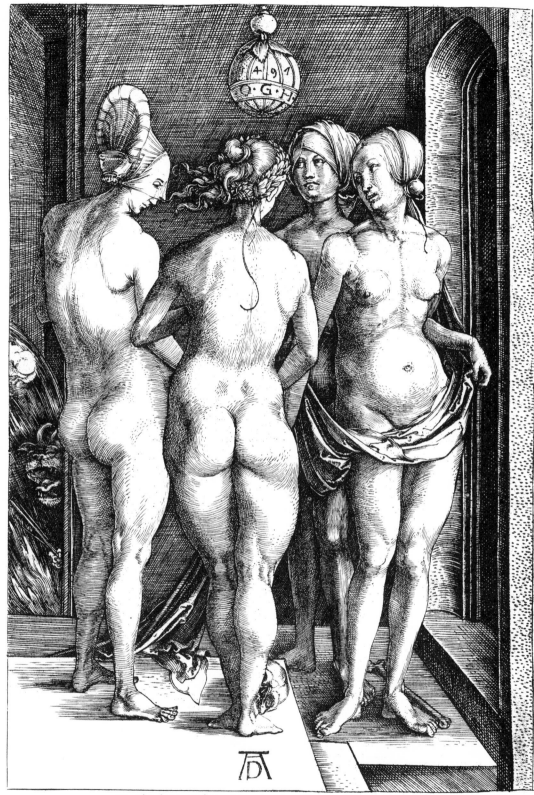

88. The four witches. Engraving by Albrecht Dürer, 1497.

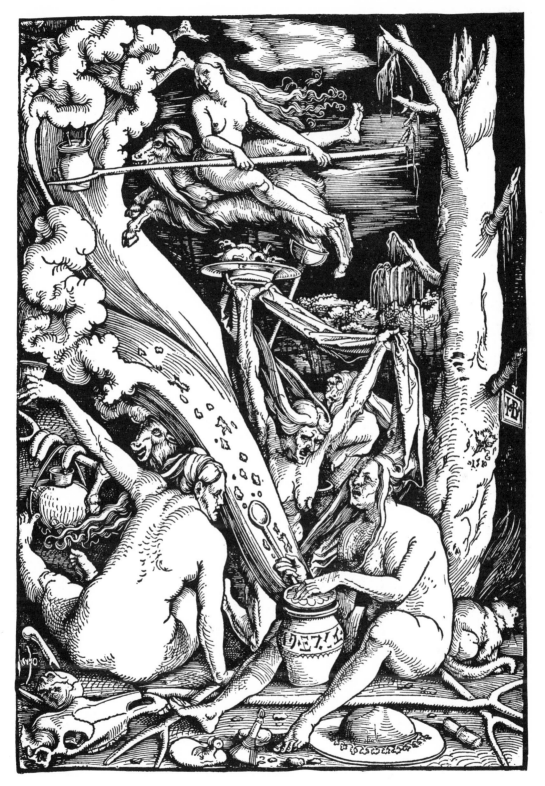

89. Witches concocting an ointment to be used for flying to the Sabbath. By Hans Baldung Grien, Strassburg, 1514.

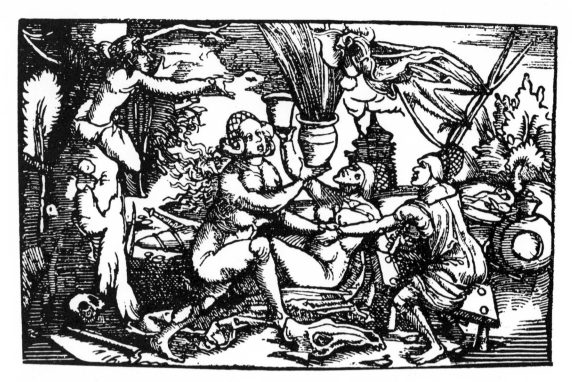

90. Witches celebrating. Woodcut by Hans Weiditz.

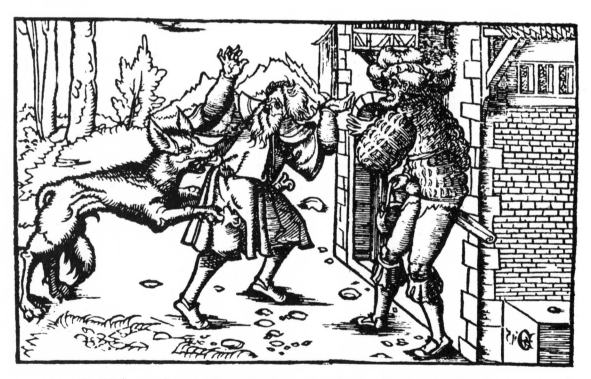

91. Witch turned werewolf attacking travelers. Woodcut by Hans Weiditz. From
Dr. Johann Geiler von Kaysersberg's *Die Emeis* (The Ants), printed by Johann Grüninger,
Strassburg, 1517.

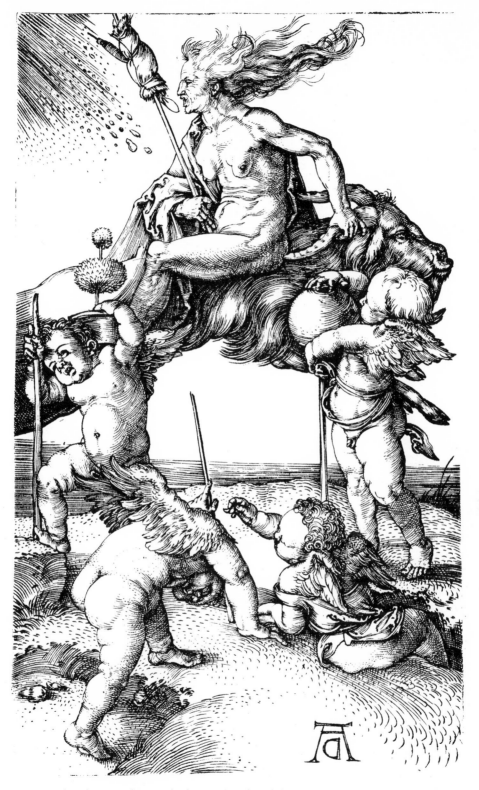

92. Witch riding on the Devil's he-goat to the *Walpurgisnacht,* goaded on by playful
amoretti. By Albrecht Dürer.

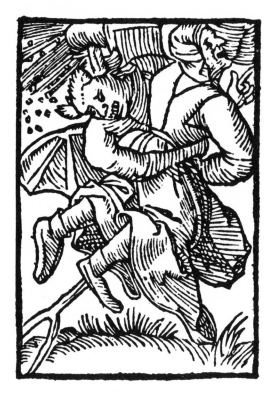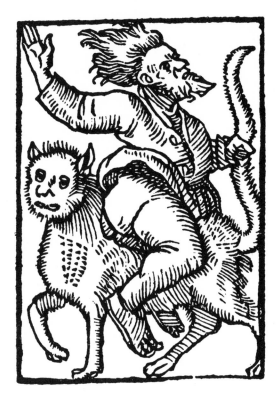

93, 94. Witch and wizard riding to the Sabbath. From Ulrich Molitor's *Hexen Meysterey,* 1545.

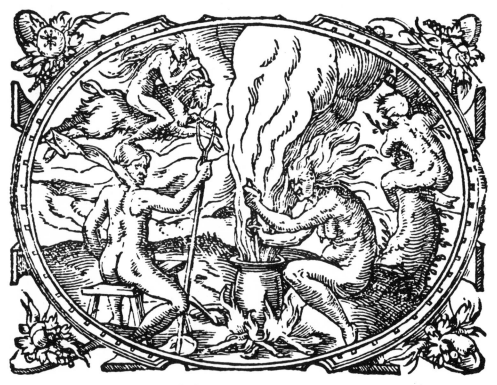

95. Witches' brew. From Abraham Saur's *Ein Kurtze Treue Warning* (A Short, True Warning), printed at Frankfurt, 1582.

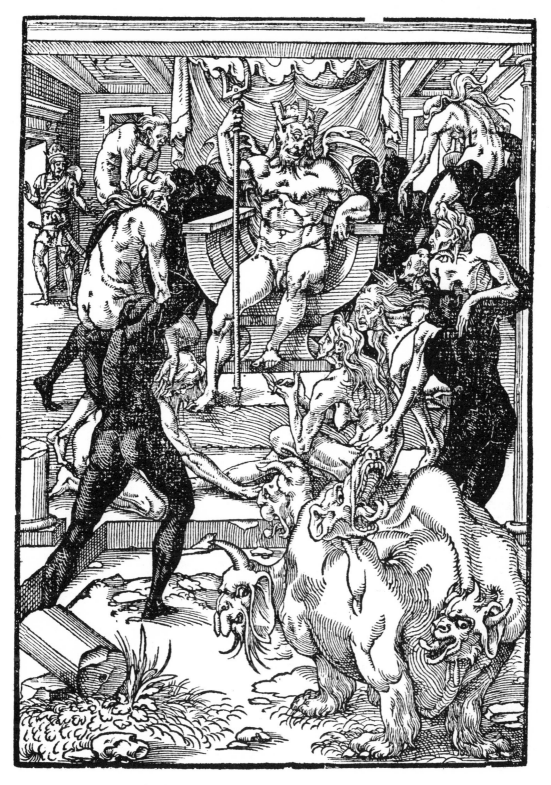

96. Satan (Pluto) holding court for newly anointed witches. From Gerard d'Euphrates'
Livre de l'histoire & ancienne cronique, printed by E. Groulleau, Paris, 1549.

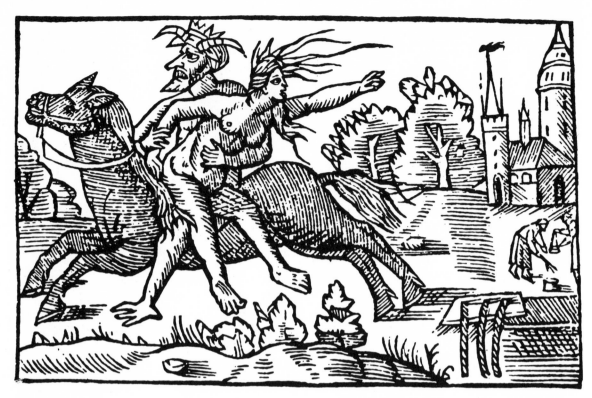

97. The Devil carrying a witch off to Hell.

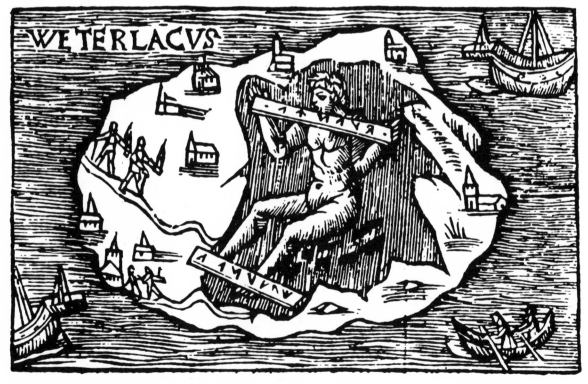

98. The sorcerer Gilbert shackled by the warlock Catillum on the isle of Weterlacus.
From Olaus Magnus' *Historia de gentibus septentrionalibus*, Rome, 1555.

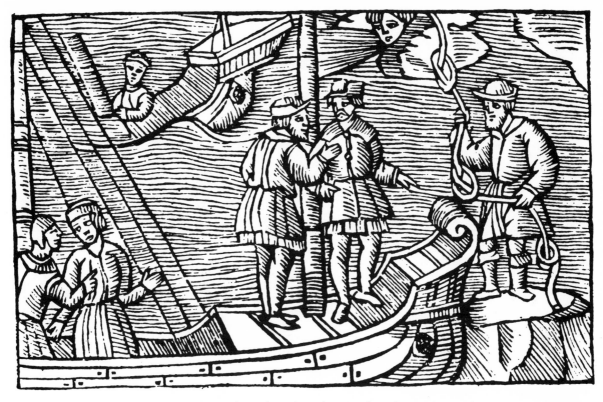

99. Sorcerer selling a bag of wind (tied up in three knots of a rope).

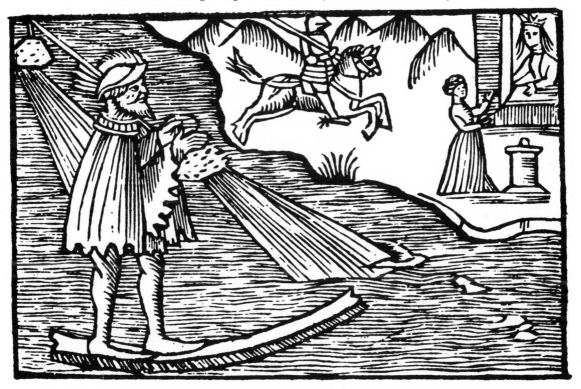

100. Sorcerer riding the waves on a piece of flotsam.
From Olaus Magnus' *Historia de gentibus septentrionalibus*, Rome, 1555.

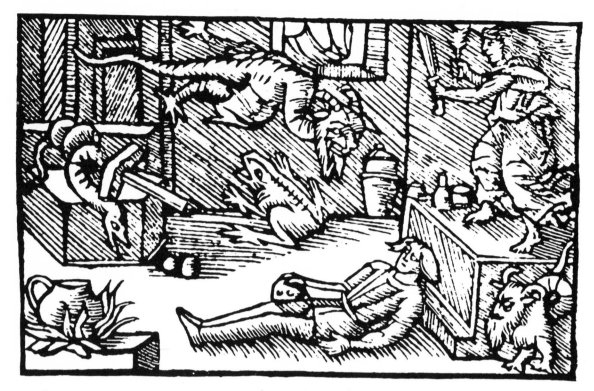

101. Witch conjuring up demons.

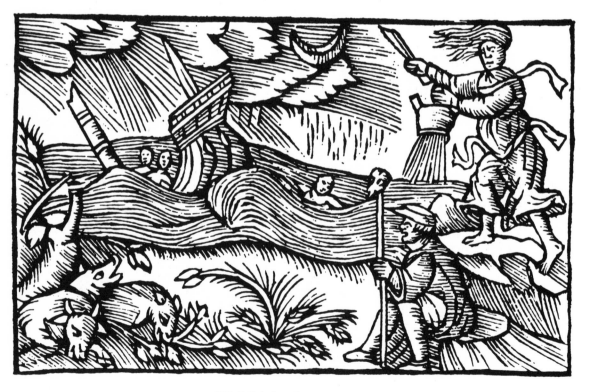

102. Witch brewing up a storm.
From Olaus Magnus' *Historia de gentibus septentrionalibus,* Rome, 1555.

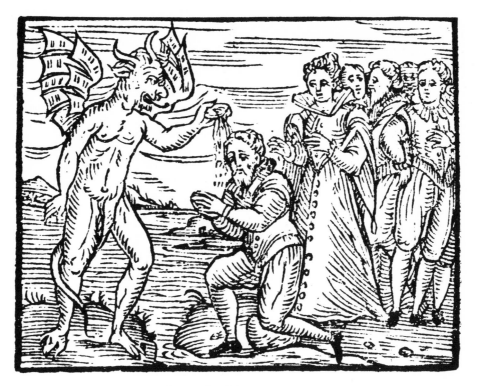

103. Satan rebaptizing young sorcerers.

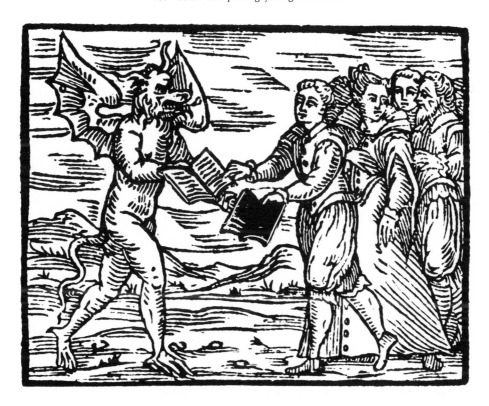

104. Sorcerer exchanging the Gospels for a book of black magic.
From R. P. Guaccius' *Compendium Maleficarum*, Milan, 1626.

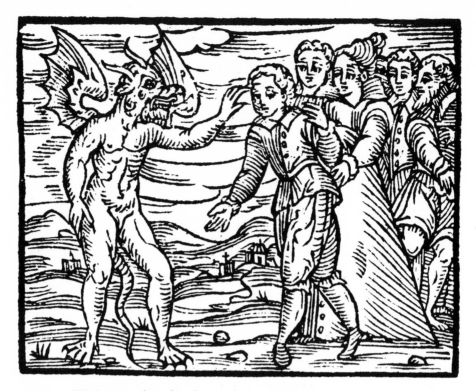

105. Satan applying his claw mark to an apprentice sorcerer.

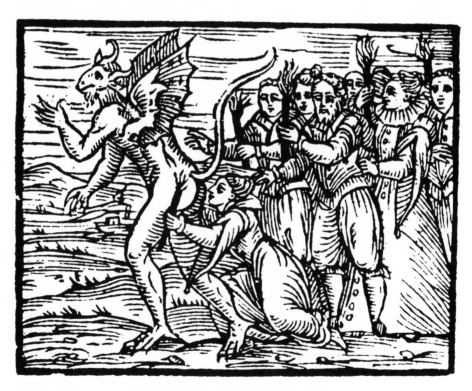

106. Witch giving the ritual kiss to Satan.
From R P. Guaccius' *Compendium Maleficarum,* Milan, 1626.

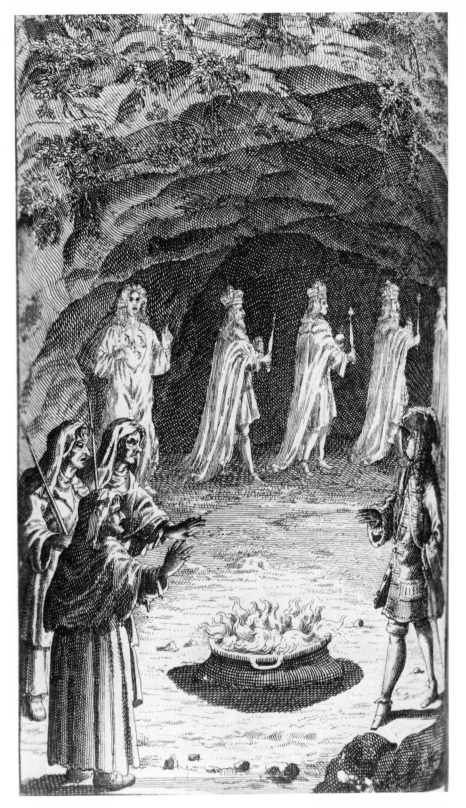

107. Macbeth and the three witches (Act IV, Scene i). From N. Rowe's first illustrated edition of *William Shakespeare's Workes*, printed by Tonson, London, 1709.

Witch-Hunting

Witchcraft was combated fiercely by both Catholics and Protestants, with civil authorities lending a firm hand to the Church. The many executions of Protestants and Jews by the Catholic Inquisition is shown in several illustrations here as an analogous phenomenon. The most famous witch hunt in America (literally speaking) took place in Salem, Massachusetts, in 1692 and had Cotton Mather as its theorist.

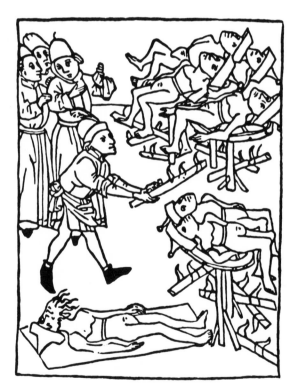

108. Torturing of Jews accused by the Inquisition as heretics and perpetrators of black magic. From a woodcut, 1475.

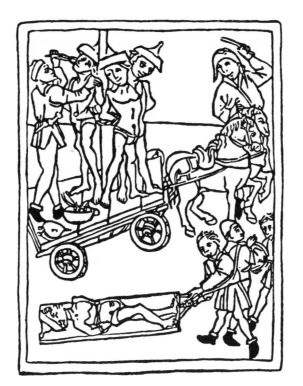

109. Another scene of torturing of Jews. Woodcut, 1475.

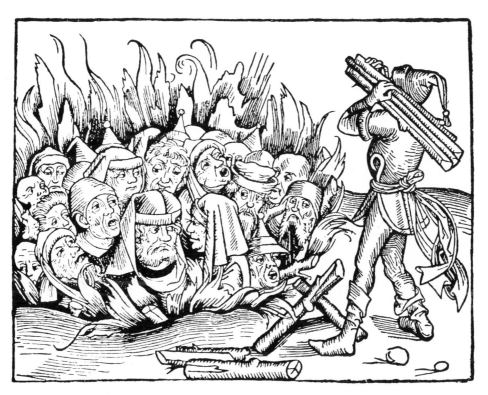

110. Protestants and Jews accused by the Inquisition of heresy and witchcraft. From a contemporary woodcut, Nuremberg, 1493.

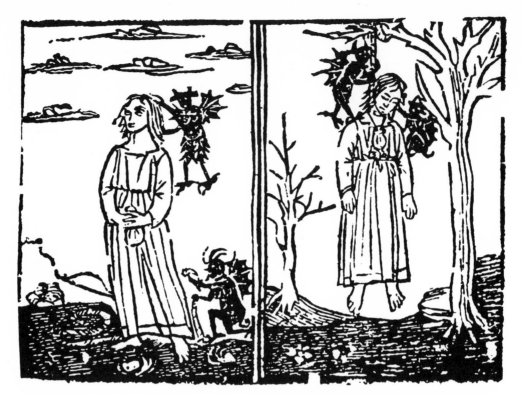

111. Hanging of a farm woman declared by the Inquisition to be possessed by demons.
From *Rappresentatione della Passione,* Florence, 1520.

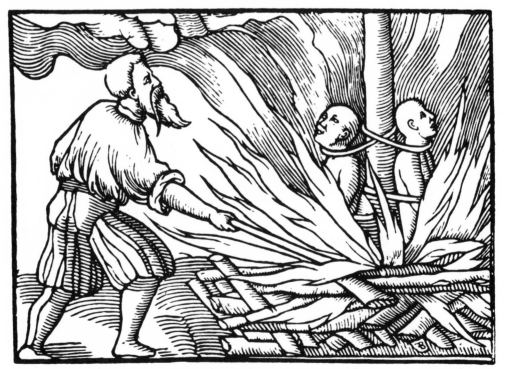

112. Two Dominican monks burned at the stake by order of the Inquisition for allegedly
signing pacts with the Devil. From the *Histoire véritable de quatre Iacopins,* Geneva,
1549.

Ein erschröckliche geschicht/ so zu Derneburg in der Graff-

schafft Reinstepn/am Hartz gelegen/von dreyen Zauberin/vnnd zwayen
Mañen/In ettlichen tagen des Monats Octobris Im 1 5 5 5. Jare ergangen ist.

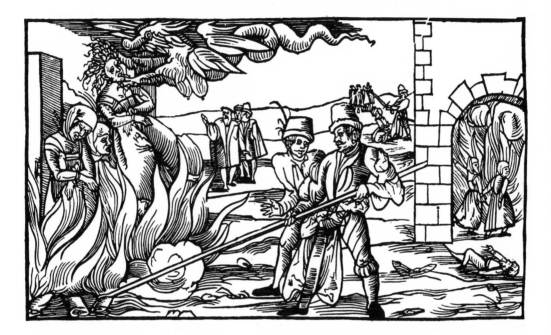

Die alte Schlang der Teüffel/dieweyl er Got/vnd zauoran den Sun Gottes/vnsern Herrn Jesum Christum/vnd das gantze menschliche ge
schlecht/fürnemlich vmb vnsers Haylands Christi willen hasset/hat er sich bald im anfang/vnd kürglich nach der erschaffung vmb dz woldß
bild/als vmb die/welcher same seinen kopff zertretten solt/angenoñen/dieselbigen durch sein hinderlist vnd lugen/zu dem jämerlichen fal/deß vn
glaubens vñ vngehorsams wider Got gebracht/Darauß das gantz menschlich geschlecht/in ewige verdamnuß vñ verderben komen were/so Chri=
stus vnser Hayland/den zorn des Vatters nicht weck genomen/vnd das gericht wider vns auffgeaben het. Nu behelt der alte Feind gleichwol al=
ten haß wider Christum/vnd vns/für vñ für/vnd helt auch sein alte weyse/er setzet sonderlich dem weiblichen geschlecht hart zu/als dem schwecheren
werckzeug/damit er sie von Christo wegreysse/vñ in ewige verdamnuß füre/vñ wie er zu Eua sprach/sie wurden werdẽ wie die Götter/Also bläst
er noch das gifft in der weyber hertzen/lernet sie zaubern/auff das sie klug mache/das sie mehr wissen dann andere leüt/vnd also den Göttern ge
leich werden/damit macht er sie im anhengig/vnd zu Teüffels dienerin/ja auch zu Teuffels brüten/wie dise jämerliche geschicht/welche warhaff=
tigklich also wie vnden angezaiget/am Hartz ergangen ist/Die derhalben also gemalet vñ geschriben/im druck auß gangen. Auff das doch die rohe
lose welt/zu Gottes forcht erwecket/vnd von dem Gottlosen wesen abgeschickt werden/Dann Got der allmächtige derhalben solche Exempel
vns sehen laße/das er damit vnsere harten hertzen durch dise erschröckliche exempel / zur forcht Göttliches gerichts/vnd straffe erwecke/man mag
es malen/predigen/singen vnd sagen/vñ wie man jmer kan den leüten einbilden/damit der laydige hauffe ein wenig zu Gottes forcht/gehorsam/
vnd zucht gezogen werde/besonder zu disen letsten zeyten/in welchẽ der listige Sathan/dieweyl er mercket/das der tag des gerichts sich nahet/gar
raffend toll vnd vnsinnig ist/vnd bede durch sich vnd seine glider/grewlicher weyse/wider Christum vnd sein armes heüfflein wüttet/Die ellende
welt aber dargegẽ so frey sicher in allem mutwillen dahin lebet/als ob der Teuffel vor langst gestorben sey/vnd kain Got/kain gericht oder straff/
verhanden were/Der Almächtig Got vnd vatter/vnsers Herrn Jesu Christi/wölle dem grimigen feinde wehren/sein armes heüfflein vor jm vnd
seinen glidern schützen vnd handthaben/seinen vnd der seinen wütten vnd toben/einmal ein ende machen/durch Jesum Christum Amen.

¶.Folget die geschichte / so zu Derneburg in der Graffschafft Reynstein am Hartz
gelegen/ergangen ist/ Im October des 1 5 5 5. Jars.

113. Broadside newsletter about the public burning of three witches at Derneburg
(Harz), October 1555.

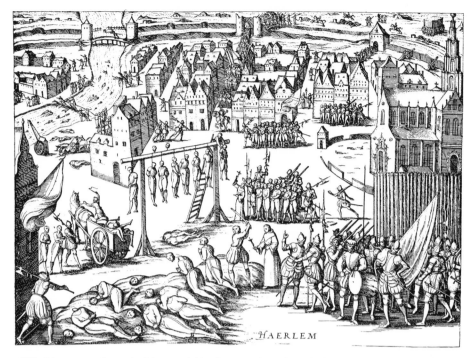

114. Mass execution of citizens of Haarlem as disciples of the Devil, under Fernando
Álvarez de Toledo, Duke of Alba, after the conquest of Haarlem in 1573.

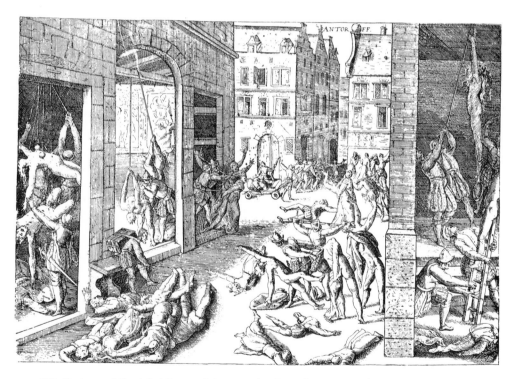

115. Torture of the inhabitants of Antwerp by Spanish troops under Fernando Álvarez
de Toledo, Duke of Alba, after the conquest of the city in 1576.
From Michael Aitsinger's *De leone Belgico*.

Relation

Oder Beschreibung so Anno 1669. den 23. Martij in der Rönnischen Reichs-Statt Augspurg ge-
schehen / von einer Weibs-Person / welche ob grausamer vnd erschröcklicher Hexerey vnd Verkreniungen der Menschen / wie auch wegen anderer verübten Vbelthaten durch ein ertheiltes gnädiges Vrtheil von eim gantzen Ehrsamen Rath / zuvor mit glüenden Zangen gerissen / hernach aber mit dem Schwerdt gericht / der Leib zu Aschen verbrennt ist worden.

Rstlich hat Anna mit Namen Eberlehrin / gewesse Kindtbeth-Kellerin von Augspurg gebürtig / gut vnd betrohlich aufgesagt vnd bekändt / daß sie vor vngefähr 13. oder vierzehen Jahren / sich mit dem bösen Geist / als er damahlen bey einer Hochzeit in Manns-Gestalt zu jhr auff den Tantz / vnd hernach in jhr Hauß kommen / der gestalt in ein heimlichen Pact vnd Verbündtnuß eingelassen / das sie nit allein demselben sich gantz vnd gar ergeben / sondern auch der Allerheyligisten Dreyfaltigkeit abgesagt / dieselbe verlaugnet / vnd dise zuevor Mündtliche gethane all zuegrausame vnd höchst Gottslästerliche Absag vnd Verlaugnung / auff begehren deß bösen Feindts / nach dem er selbige selbst zu Papier gebracht / vnd jhr die Hand geführt / auch so gar mit jhrem Blut vnderschriben vnd bekräfftiget / von welcher Zeit an sie mit dem laidigen Sathan auch manches mahlen Vnzucht getriben: Deßgleichen auß antrib desselben durch eine von jhme empfangnes weisses Pülverleins wenigist 5. Personen / vnd darunder 4. vnschuldige vnmündige Kinder elendiglich hingerichtet / vnd vmbs Leben gebracht / nit weniger habe sie jhren leibeignen Bruder durch ein dergleichen jhme im Trunck beygebrachtes Pülverleins verkrümbt / vnd dardurch sowol demselben als andern Menschen mehr / die entweders an jhren Leibern Knüpffel oder sonsten grosse Kopffwehe bekommen / zu mahlen dem Vieh durch Hexerey vnd zauberische Mittel geschadet / auch darunder zwey Pferdt gar zu schanden gemacht / Ferners habe sie auch nit allein durch grausam fluchen vnd schwören mit zuthun deß bösen Feindts etliche Wetter gemacht / darunder eines zu Guntzburg eingeschlagen / vnd grossen Schaden gethan / sondern auch vermittelst Nächtlicher Auffahrt rens zu vnderschidenen mahlen bey den Hexen-Täntzen vnd Ver-

samblungen sich eingefunden / vñ darbey dem bösen Geist mit Kniebiegen vnd dergleichen solche Ehr bewisen die sonsten GOtt dem Allmächtigen allein gebühre. So hat sie auch über daß noch weiters aufgesagt vñ bekändt / daß sie in Zeit diser jhrer mit dem bösen Feind gehabten gemein vnd Kundtschafft einsmahls vngebeichtet das Hochwürdige heylige Sacrament deß Altars empfangen vñ genossen / auch sich vnderstanden / nit allein durch jhr vergifftes Teufflisches Pulver vñ anders / zwey Weibs-Personen vnfruchtbar zumachen / bey deme es aber ausser einer nit angangen seye / sondern auch ein Mägdlein vnd einen jungen Knaben zu den Hexen-Täntzen mit genommen vnd verführt.

Ob welcher vnd anderer verübter vilfältiger schwerer vnd grausamerer Vnthaten / vnd Verbrechen halber ein Ehrsamer Rath mit Vrtheil zu Recht erkändt / daß jhr Eberlehrin obwolen sie denen Rechten nach lebendig verbrennt zu werden verdient hette / dannoch auf Gnaden allein mit glüenden Zangen am Auffführen drey Griff gegeben / vnd sie bey der Richtstatt mit dem Schwerdt vnd blutiger Hand vem Leben zum Todt hingericht / auch der Cörper zu Aschen verbrandt solle werden.

A Die Abführung ab dem Tantz / vnd in Anna Eberlehrin Behausung Einführung von dem Teuffel.
B Die Außführung Nächtlicher weil mit dem bösen Feindt.
C Die Beywohnungen der Hexen-Täntzen.
D Die Herlischen Z'amenkunfften vnd Teufflische Malzeiten.
E Verhörung vnd Aussag wegen jhrer verübten Hexereyen.
F Verführung zweyer jungen vnschuldiger Kinder / als eines Knaben vnd Mägdlein.
G Anna Eberlehrin Außführung zu dem Gericht / vnd wie sie mit glüenden Zangen gerissen wird.
H Die Hinrichtung vnd Verbrennung zu Aschen jhres Leibs.

Zu Augspurg bey Elias Wellhöffe / Brieffmaler bey vnser L. Frawen Thor.

116. Newsletter about the infernal deeds and the execution of the witch Anna Eberlehrin, printed by Elias Wellhöffe, "Briefmaler" at Augsburg, 1669.

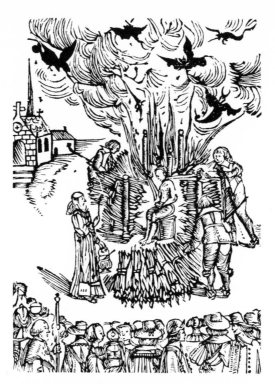

117. The public burning of Father Urbain Grandier for signing a pact with the Devil.
From a contemporary drawing, Loudun, 1634.

118. The pact with the infernal powers allegedly signed by Father Urbain Grandier and
countersigned by Lucifer, Beelzebub, Satan, Elimi, Leviathan, Asteroth and Baalbarith.
Loudun, 1634.

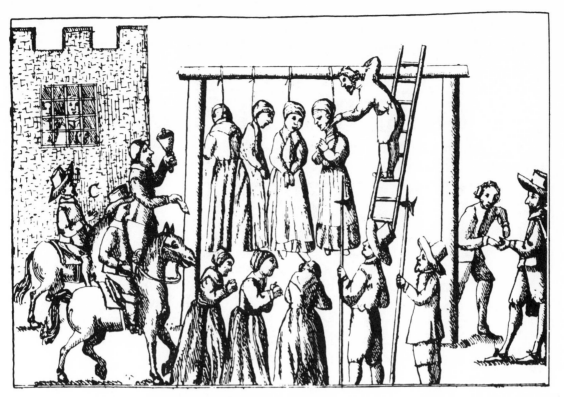

119. Public hanging of witches. From Sir George Mackenzie's *Law and Customs of Scotland in Matters Criminal,* Edinburgh, 1678.

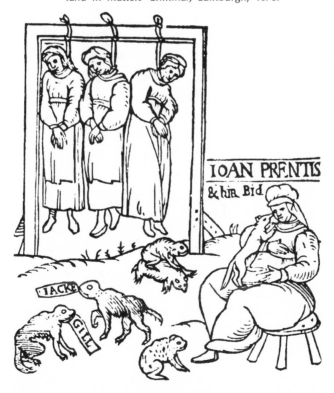

120. The public hanging of the three Chelmsford witches Joan Prentice, Joan Cony and Joan Upney. From an English pamphlet, 1589.

The Wonders of the Invisible World.

OBSERVATIONS

As well *Historical* as *Theological*, upon the NATURE, the NUMBER, and the OPERATIONS of the

DEVILS.

Accompany'd with,

I. Some Accounts of the Grievous Molestations, by DÆ-MONS and WITCHCRAFTS, which have lately annoy'd the Countrey; and the Trials of some eminent *Malefactors* Executed upon occasion thereof: with several Remarkable *Curiosities* therein occurring.

II. Some Counsils, Directing a due Improvement of the terrible things, lately done, by the Unusual & Amazing Range of EVIL SPIRITS, in Our Neighbourhood: & the methods to prevent the *Wrongs* which those *Evil Angels* may intend against all sorts of people among us, especially in Accusations of the Innocent.

III. Some Conjectures upon the great EVENTS, likely to befall, the WORLD in General, and NEW EN-GLAND in Particular; as also upon the Advances of the TIME, when we shall see BETTER DAYES.

IV. A short Narrative of a late Outrage committed by a knot of WITCHES in *Swedeland,* very much Resembling, and so far Explaining, *That* under which our parts of *America* have laboured!

V. THE DEVIL DISCOVERED: In a Brief Discourse upon those TEMPTATIONS, which are the more Ordinary *Devices* of the Wicked One.

By Cotton Mather.

Boston Printed by *Benj. Harris* for *Sam. Phillips.* 1693.

121. Title page from one of Cotton Mather's witch-hunt pamphlets, printed by Benjamin Harris for Samuel Phillips, Boston, 1693.

The Wonders of the Invisible World :

Being an Account of the

TRYALS

OF

Several Witches,

Lately Excuted in

NEW-ENGLAND:

And of several remarkable.Curfosities therein Occurring.

Together with,

I. Obfervations upon the Nature, the Number, and the Operations of the Devils.

II. A fhort Narrative of a late outrage committed by a knot of Witches in *Swede-Land*, very much refembling, and fo far explaining, that under which *New-England* has laboured.

III. Some Councels directing a due Improvement of the Terrible things lately done by the unufual and amazing Range of *Evil-Spirits* in *New-England*.

IV. A brief Difcourfe upon thofe *Temptations* which are the more ordinary Devices of Satan.

By *COTTON MATHER.*

Publifhed by the Special Command of his EXCELLENCY the Governeur of the Province of the *Maffachufetts-Bay* in *New-England.*

Printed firft, at *Bofton* in *New-England* ; and Reprinted at *London,* for *John Dunton,* at the *Raven* in the *Poultrey.* 1693.

122. Title page from another edition of Cotton Mather's witch-hunt pamphlet, reprinted from the Boston edition for John Dunton, London, 1693.

Ars Moriendi

In medieval belief, demons lay in wait at the bedside of the dying in hopes of snatching away their souls. The book *Ars Moriendi* (The Art of Dying), which appeared in many block-book editions (both words and pictures cut on the same wood block) in the late fifteenth century, depicted the struggle between vices (and religious doubts) and virtues (religious certainty) in the mind of the dying man and the fight between externalized good and evil forces over his soul.

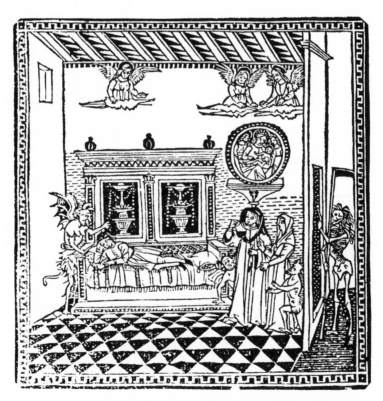

123. Death chamber. From an Italian *Arte del Bene Morire*, Florence, about 1495.

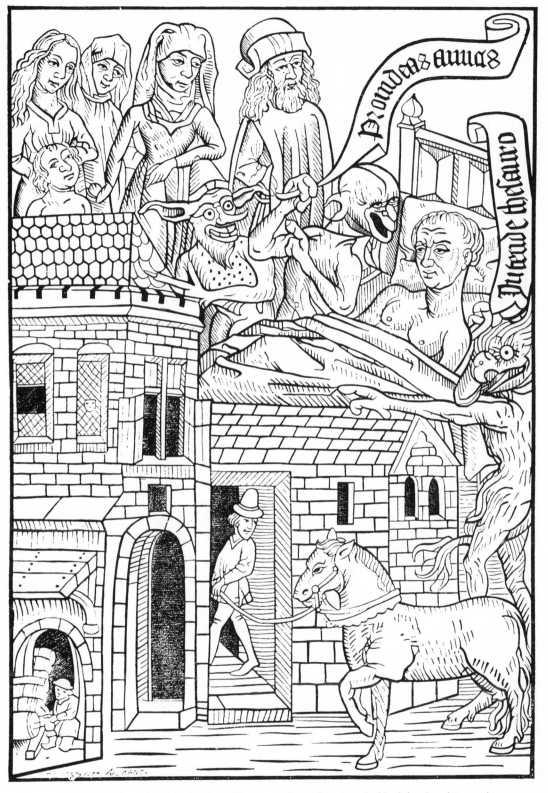

124. Temptation through Avarice. From a xylographic French block-book edition of
Ars moriendi, 1465.

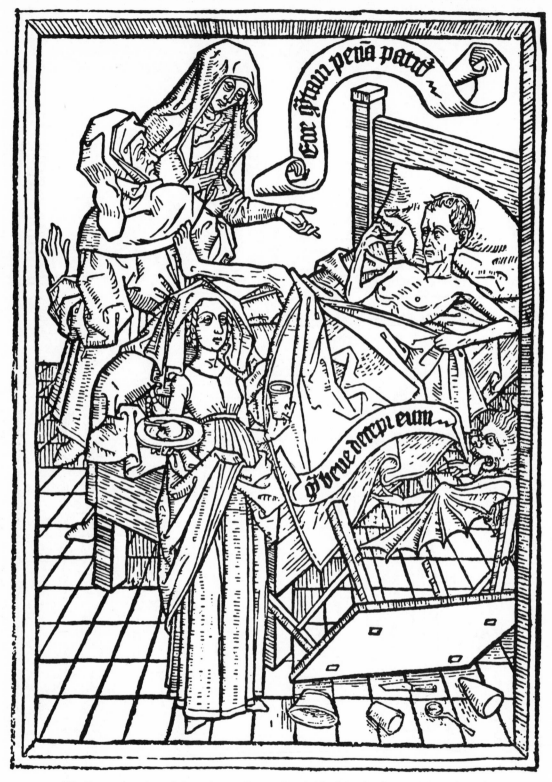

125. Temptation through Impatience. From a Dutch block-book edition of *Ars Moriendi,*
1465.

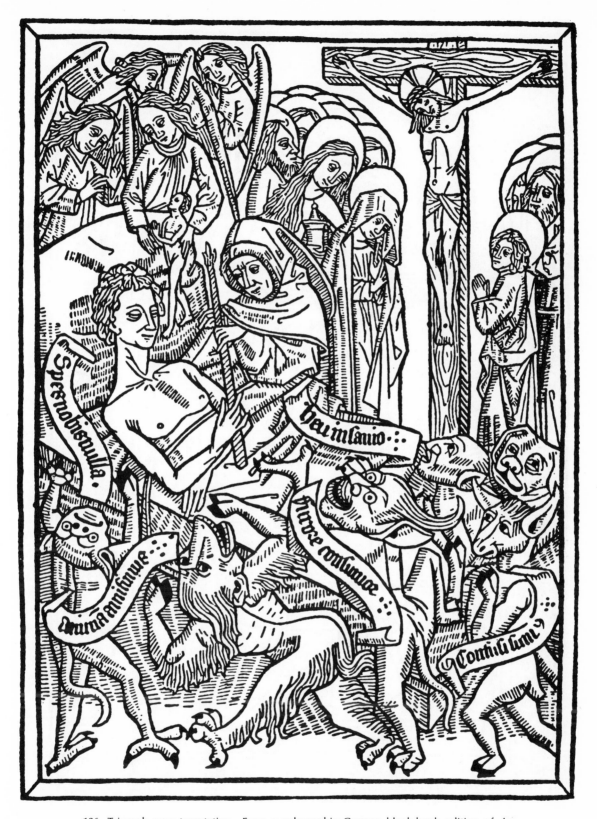

126. Triumph over temptation. From a xylographic German block-book edition of *Ars Moriendi*, Augsburg, 1471.

127. Confession in church as a preparation for easy dying. From Dominicus Capranica's *De Arte bene moriendi,* printed by Johann Clein and Piero Himel, Venice, 1490.

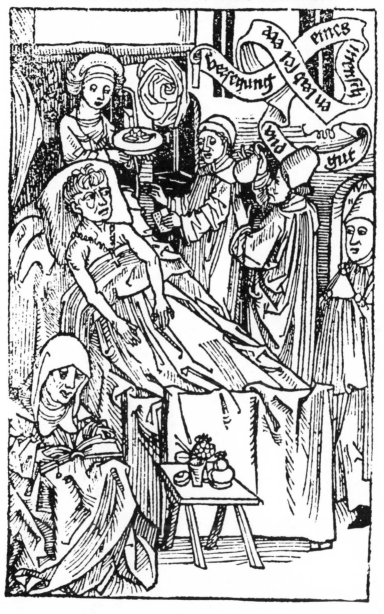

128. Dying man surrounded by his attendants. Attributed to Albrecht Dürer; from the title page of a German edition of *Ars Moriendi,* printed by Johann Weyssenberger, Nuremberg, 1509.

Danse Macabre

A favorite medieval theme, connected with the view of the world as mere vanity, was the leveling of all social classes and ranks in death—with Death aptly personified as the bare, unidentifiable, universal skeleton. At first in church frescoes and then in dozens of books, the theme of Death seizing all men from emperors to peasants became popular throughout Europe. The woodcut illustrations of the *Dance of Death* by Hans Holbein the Younger (eight of which are reproduced in this chapter) are the most famous of all.

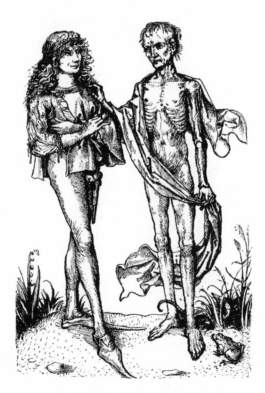

129. Death and the young man. From a Danse Macabre engraving by the Master of the Housebook, Germany, 1490.

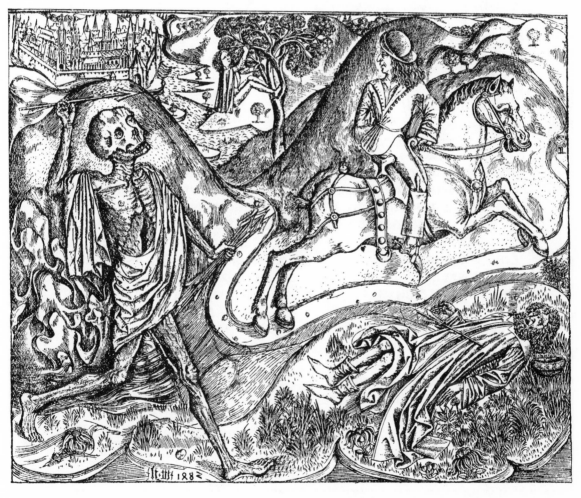

130. Death and the hunting party, an allegoric representation of the might of Death.
Engraving by Master H. W. (Wolf Hammer), Austria, 1482.

Er vtero natis posita est ler ire: sed esse
Certos: sub sole perpetuare nichil.
Et vero n atis pedetentim calle sub ipso
Subdola mors comes est: nos laqueare studens.

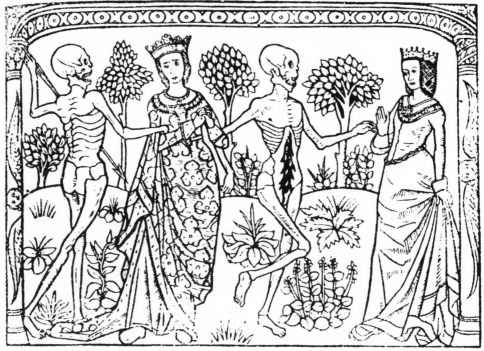

La morte

Noble royne de beau courage
Gente et ioyeuse a laduenant:
Jay de par le grât maistre charge
De vous en mener maintenant
Et comme bien chose aduenant
Ceste dance commencerez.
Faitez deuoir au remenant
Vous qui viuez ainsi ferez.

La royne

Ceste dance mest bien nouuelle
Et en ay le cueur bien surpris
Hee dieu: quelle dure nouuelle
A gens qui ne lont pas appris
Las en la mort est tout compris
Royne.dame.grant ou petite
Les plus grâs sôt les pmiers prins
Contre la mort na point de fuyte

La morte

Apres ma dame la duchesse
Vous vien querir et pourchasser
Ne pensez plus a la richesse:
A biens ne ioyaulx amasser.
Auiourduy vous fault trespasser.
Pour quoy de vostre vie est fait
Folie est de tant embrasser.
On nemporte que le bienfait.

La duchesse

Je nay pas encore trente ans
Helas: a leure que commence
A sauoir que cest de bon temps
Mort me vient tolly ma plaisance
Jay des amis. et grant cheuance.
Soulas. esbas. gens a deuis
pour quoy moigz me plaist cest dâce
Gens aises si meurent ennyes.

c. iii.

131. Page from *La dance Macabre des Femmes,* printed by Guyot Marchant, Paris, 1486.

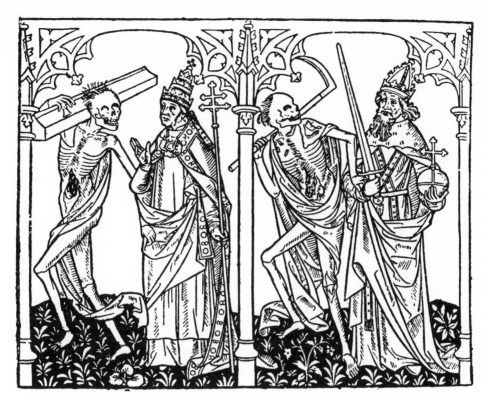

132. Pope and Emperor.
From *La dance Macabre des Hommes,* printed by Antoine Vérard, Paris, 1486.

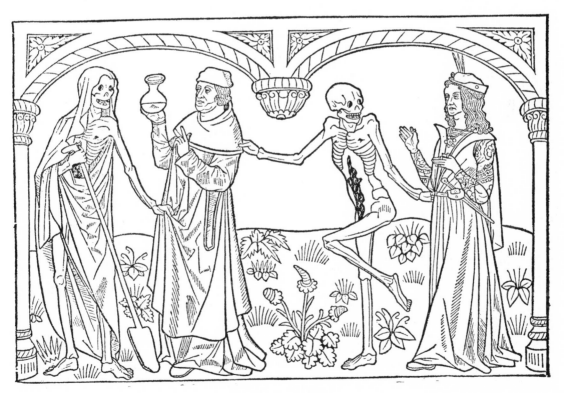

133. Doctor and lover.
From *La dance Macabre des Hommes,* printed by Guyot Marchant, Paris, 1486.

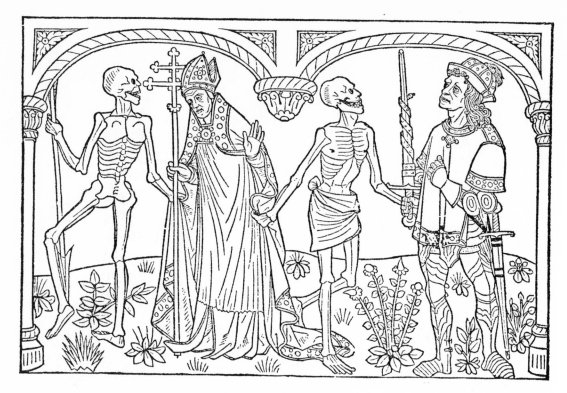

134. Pope and Emperor.

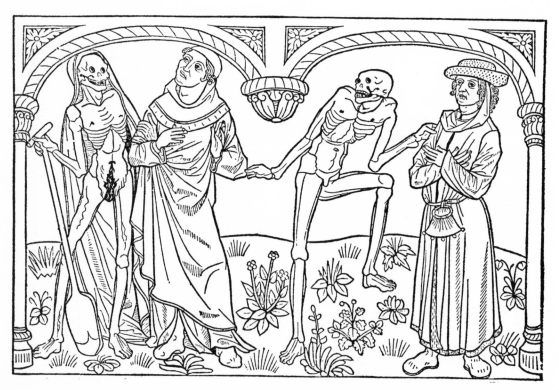

135. Astrologer and bourgeois.
From *La dance Macabre des Hommes,* printed by Guyot Marchant, Paris, 1486.

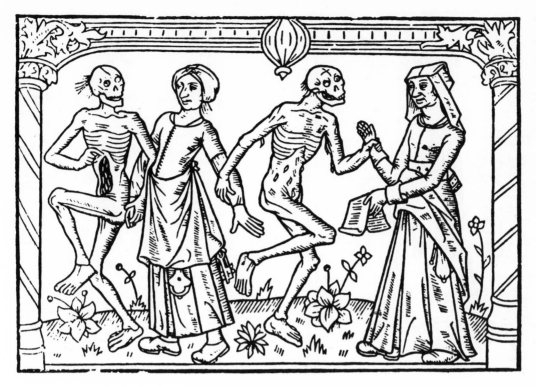

136. Chambermaid and matron.

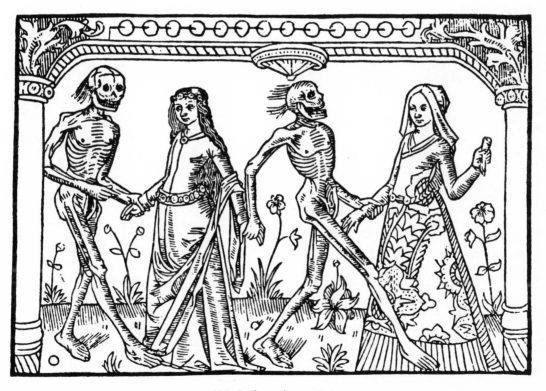

137. Bride and prostitute.
From *La dance Macabre des Femmes*, printed by Antoine Vérard, Paris, 1486.

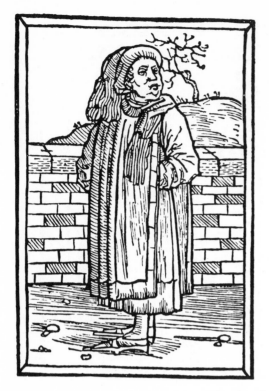
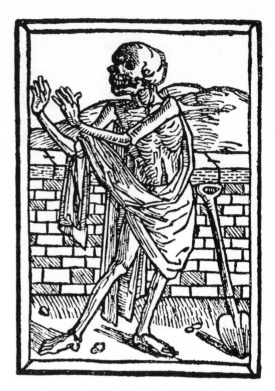

138, 139. The townsman and Death.

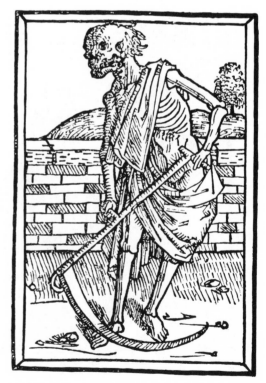

140, 141. The countryman and Death.
From the *Dance of Death* by the Master of the Lübeck Bible, Lübeck, 1489.

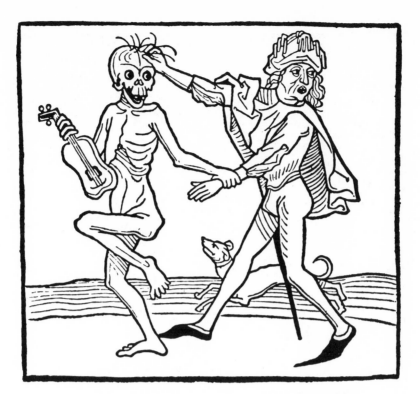

142. Death and the gentleman. From *Der Doten Dantz* (Dance of the Dead), printed by Heinrich Knoblochzer, Heidelberg, 1490.

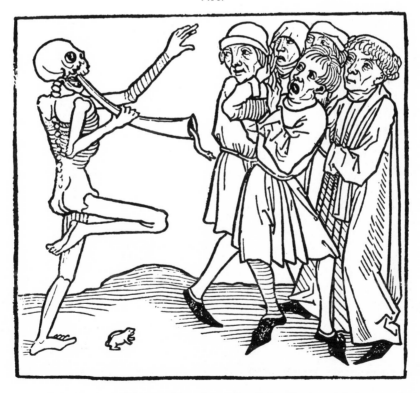

143. Death and the notables. From *Der Doten Dantz*, printed by Jacob Meydenbach, Mainz, 1492.

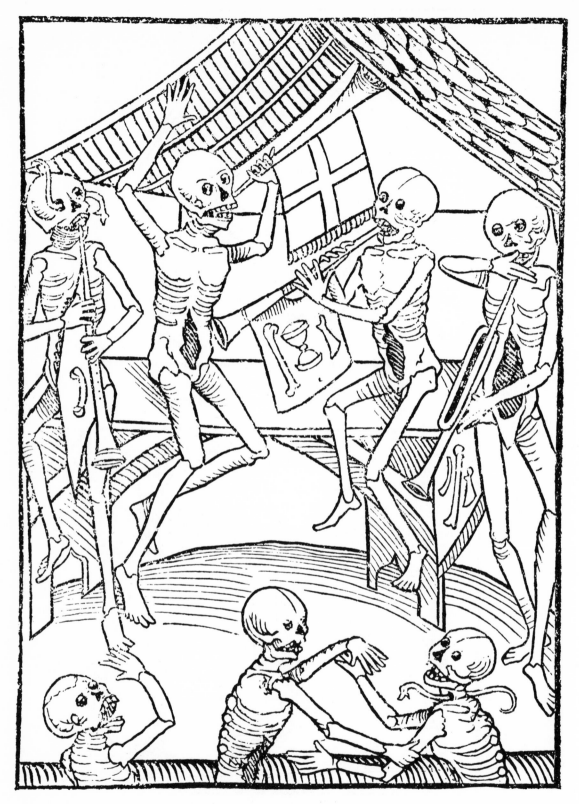

144. The orchestra of Death. From *Der Doten Dantz,* printed by Heinrich Knoblochzer, Heidelberg, 1490.

Er Jungfer
furt myr mit
fien dantzen
Hofyeren vñ
houelichen
schwantzen.
Kompt zü
stunt ich kan
nyt beyden.
Zum dantze
wilt ich uch
leyden Dwern schonen hoiff mußet yr
nu laißen Dnd in der stat dye schonē
straißen. Wollofft zum dantz yß ist
nü zijt Das yr goit von vwern wer
ken antworten syt.

Richer goit
wanne kont
met der doie
Der mich brē
get in soliche
noit Salich
yrzunde ant
wort geben.
Don all my
nem sundilt
chem leben So betrube ich mych in
den wit Das ich nyt hyelde das goes
geboit Ich han wolküst gesucht off er
den Myn sele wolle goire zu deyl wer
den.

Der toit. Der iunckher

Xv

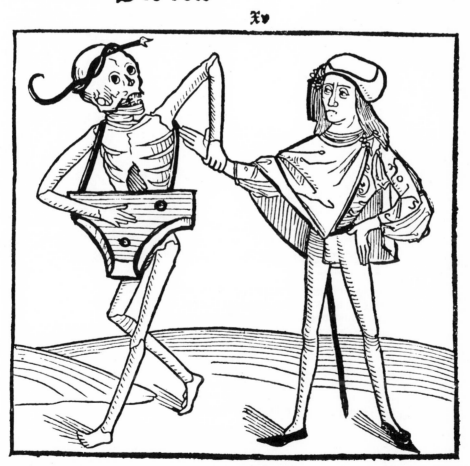

145. Death and the landowner. From *Der Doten Dantz,* printed by Heinrich Knob-
lochzer, Heidelberg, 1490.

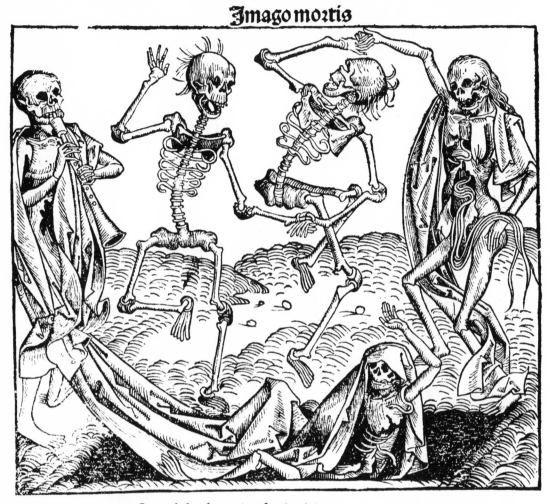

146. Orchestra of the dead. Woodcut by Michael Wolgemut, from Hartmann Schedel's *Liber Chronicarum*, printed by Anton Koberger, Nuremberg, 1493.

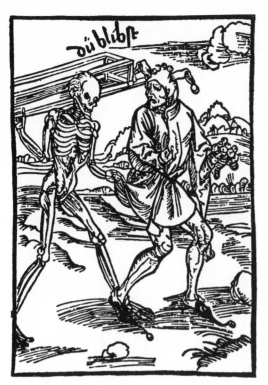

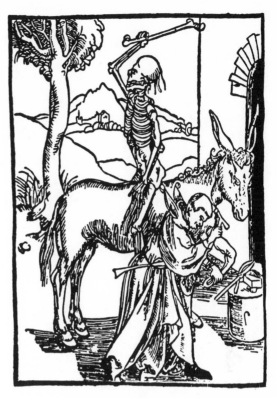

147. Death and the miserly fool.

148. Death and the poor fool.

From Sebastian Brandt's *Navis Stultifera* (Ship of Fools); attributed to Albrecht Dürer; printed by Bergman de Olpe, Basle, 1494.

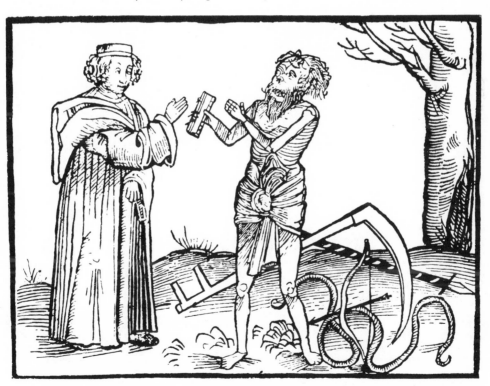

149. The physician's discussion with Death. From Strub's *Orationes Dual*, Vienna, 1511.

¶ Hic incipiunt vigilie mortuorum

150. Three revelers meet three corpses who warn them to repent. From *Horae*, printed by Wynkyn de Worde, Westminster, 1494.

A grant danse macabree des hômes & des femmes hystoriee & augmentee de beaulx ditz en latin.

Le debat du corps & de lame
La complaincte de lame damnee
Exhortation de bien vivre & bien mourir
La vie du mauuais antechrist
Les quinze signes
Le iugement.

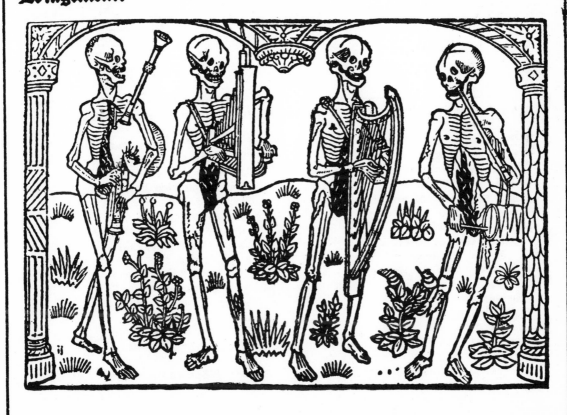

151. Dance orchestra of Death. From *La grant danse macabre des hommes et des femmes*, printed by Nicolas Le Rouge, Troyes, 1496.

¶ Mors resecat/mors omnie necat quod carne creatur / Magnificos premit & modicos/cunctis dominatur.

¶ Nobilium tenet imperium nulli reueretur / Tam ducibus & principibus communis habetur.

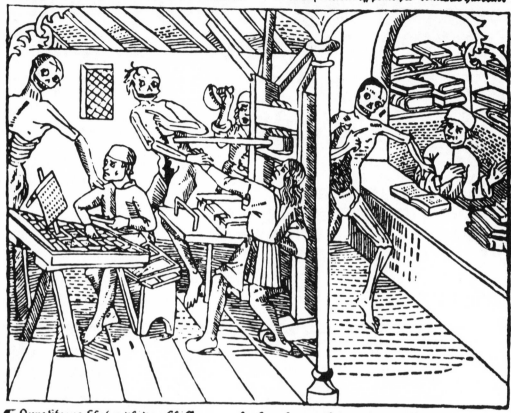

¶ Nunc ubi rus ubi scp, ubi uop, ubi flos iuuenilis hic nisi pus/nisi fep/nisi terra putrida uilis.

¶ Le mort

¶ Venez danser vng tourdion
Imprimeurs sus legierement
Venez tost pour conclusion
Mourir vous fault certainement
Faictes vng sault habillement
Dresses & casses vous fault laisser
Reculer np fault nullement
A louurage on congnoist louurier.

¶ Les imprimeurs

¶ Helas ou aurons nous recours
Puis que la mort nous espie
Imprime auons tous les cours
De la saincte theologie
Loix decret & poeterie
Dur art musicque sont grans clers
Reserue en est clergie
Les voulous des gens sont diuers

¶ Le mort

¶ Sus auant vous tres apres
Maistre libraire marchez auant
Vous me regardez de bien pres
Laissez voz liures maintenant
Danser vous fault a quel galant
Mettez icy vostre pensee
Comment vous reculez marchant
Comencement nest pas fusee

¶ Le libraire

¶ Me fault il maulgre moy danser
Je croy que ouy mort me presse
Et me contrauiet de me auancer
Nesse pas dure destresse
Des liures il fault que ie laisse
Et ma boutique desormaie
Dont ie pers toute spesse
Tel est bleu qui nen peult mais.

152. Typesetter, printer and bookseller. From *La Grant Dance Macabre,* printed by Matthias Huss, Lyons, 1499.

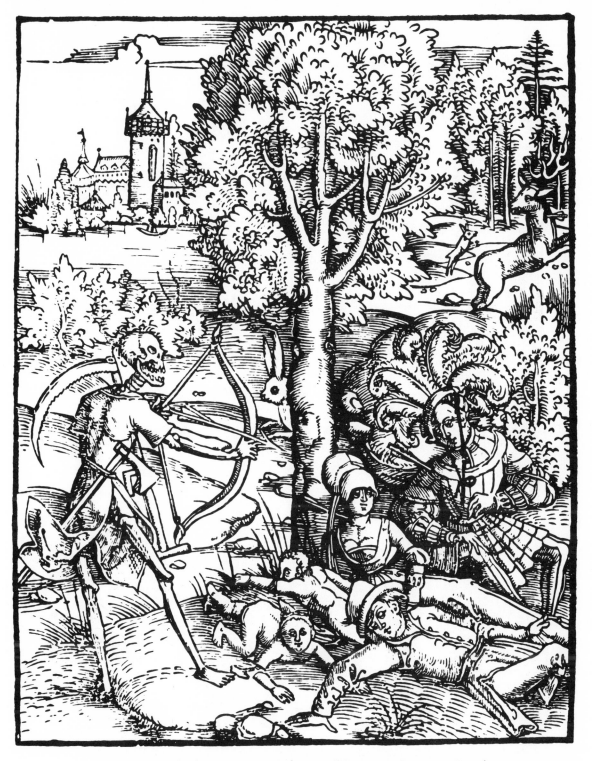

153. Death hunting the hunters. From Geiler von Kaisersperg's *Sermones, De arbore humana*, printed by Johann Grüninger, Strassburg, 1514.

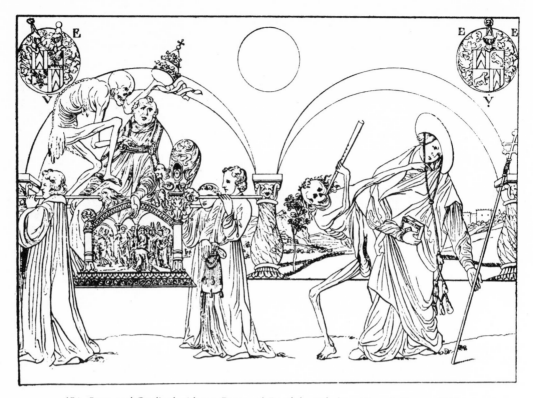

154. Pope and Cardinal. After a *Dance of Death* by Nikolaus Manuel, Berne, 1515.

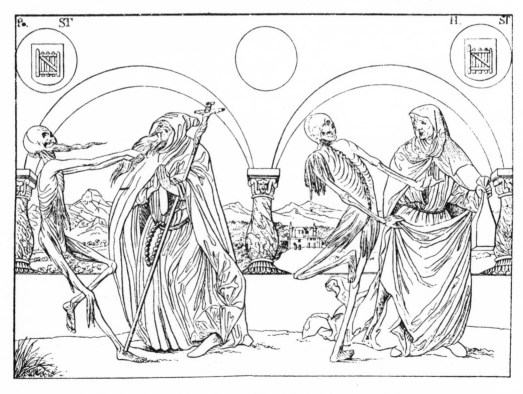

155. Monk and nun. After a *Dance of Death* by Nikolaus Manuel, Berne, 1515.

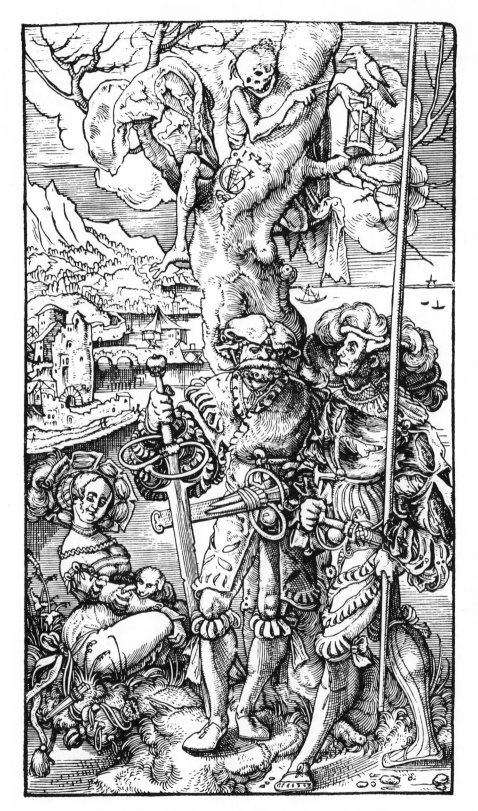

156. Death and the lansquenets. Woodcut by Urs Graf, 1524.

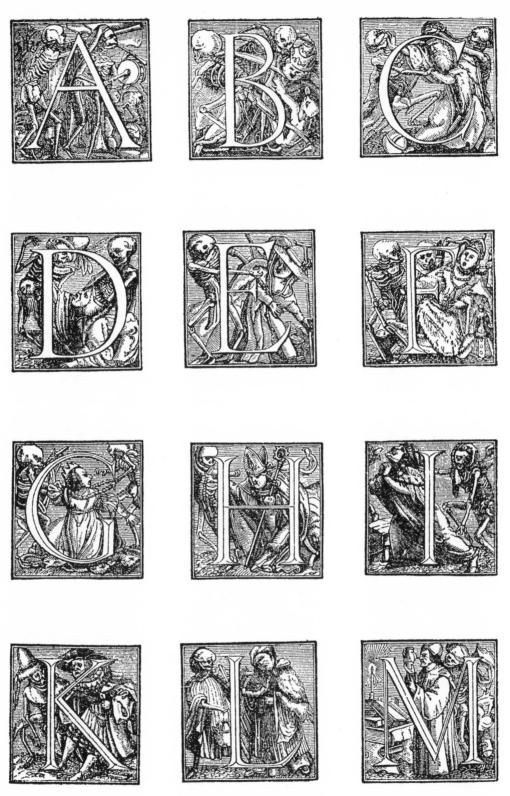

157. First half of Dance of Death Alphabet. Designed by Hans Holbein the Younger and engraved on wood by Hans Lützelburger, Basle, 1526.

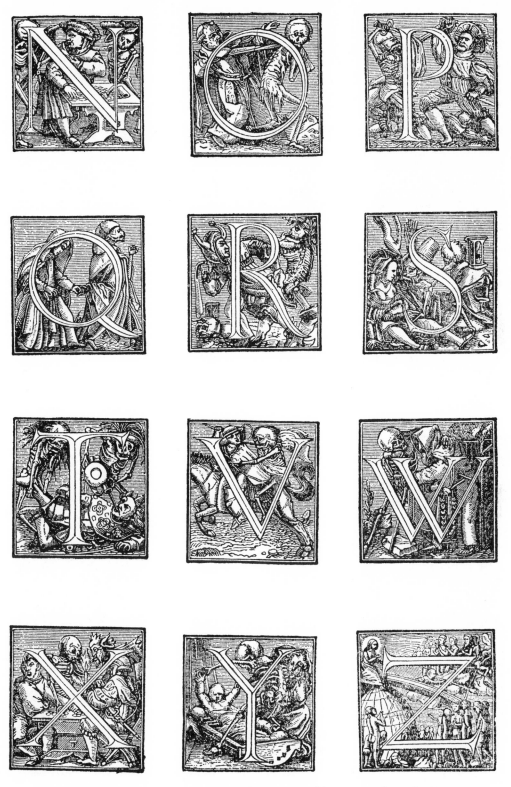

158. Second half of Dance of Death Alphabet. Designed by Hans Holbein the Younger
and engraved on wood by Hans Lützelburger, Basle, 1526.

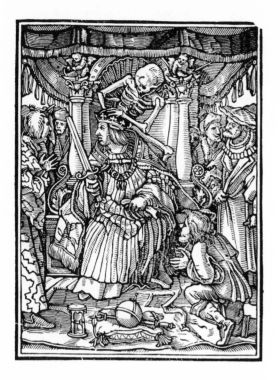
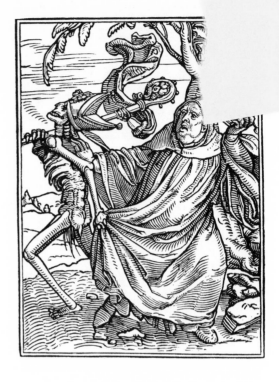
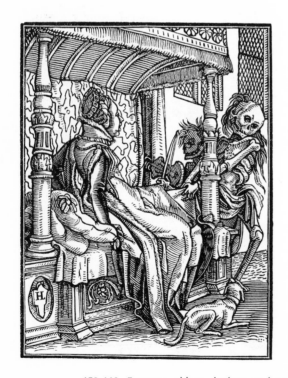
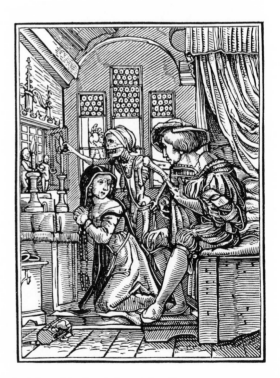

159-162. Emperor, abbot, duchess and nun. From *Imagines Mortis,* designed by Hans
Holbein the Younger and printed by J. Frellon, Lyons, 1547.

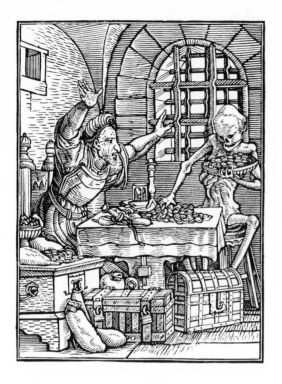
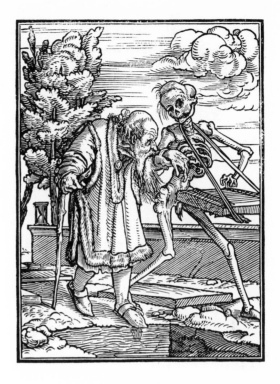
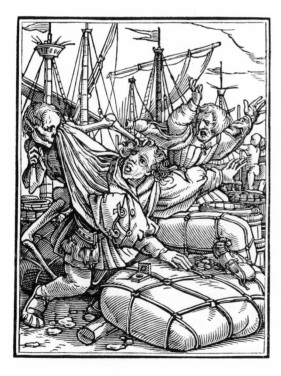
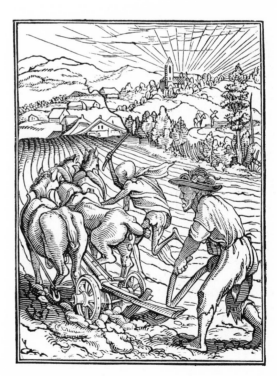

163-166. Rich man, old man, merchant and farmer. From *Imagines Mortis,* designed by
Hans Holbein the Younger and printed by J. Frellon, Lyons, 1547.

The daunce of Machabree.

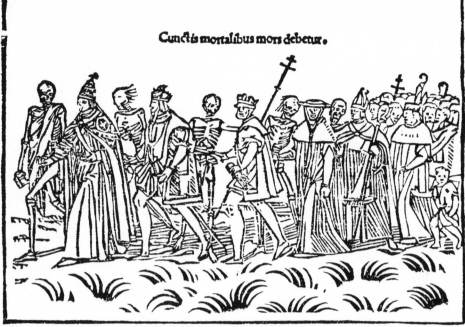

Cunctis mortalibus mors debetur.

Death fyrſt ſpeaketh vnto the Pope, and after to euery degree as foloweth.

On this daunce with other for to trace,
For which al honor, who prudently can ſee,
is litle worth that doth ſo ſoone paſſe.

Death ſpeaketh to the Emperour.

(dignitie.
E ꝥ been ſet moſt in high
Of al eſtates in earth
ſpirituall,
And like as Peter hath
the ſoueraintee,
Ouer the church and
ſtates temporall,
vpon this daunce ye firſt begin ſhall,
As moſt worthy lord and gouernour,
For al the worſhip of your eſtate Papall,
And of Lordſhip to god is the honour.

The Pope maketh aunſwere.

F yrſt me behoueth this daūce for to lede
which ſat in earth higheſt in my ſee,
the ſtate ful perilous whoſo taketh hede,
To occupie Peters dignitee,
But for al that, death I may not flee,

S Yꝛ Emperour lord of al the grounde
ſouereine prince & higheſt of nobleſſe,
ye mot forſake of gold your apple roūd
ſcepter and ſwerde & al your high proweſſe
behind leten your treaſour and your riches
And with other to my daunce obey,
Againſt my might is worth none hardines,
Adams children al they muſt deye.

The Emperour maketh aunſwer.

I Note to whom that I may appeale,
touching death which doth me ſo côſtrein
there is no gin to helpen my querel,
but ſpade and pickoys my graue to atteyne
A ſimple ſhete there is nomore to ſeyn,
to wrappen in my body and viſage,
wherupon ſore I me compleyne,
That Lordes great haue litle auauntage.
Death

167. "The daunce of Machabree," from John Lydgate's *The Fall of Princes,* printed by Richard Tottel, London, 1554.

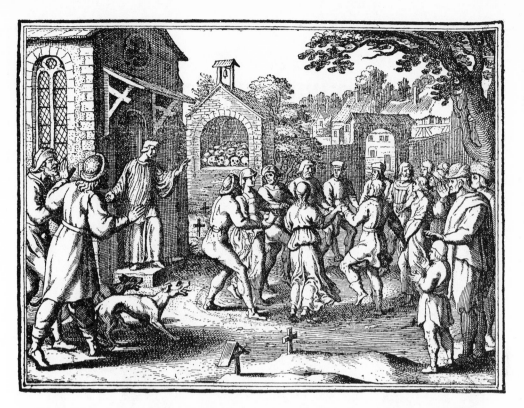

168. Religious fanatics dancing amid the graves in a churchyard, in defiance of civilian superstition and ecclesiastic ukases. From a German engraving, about 1600.

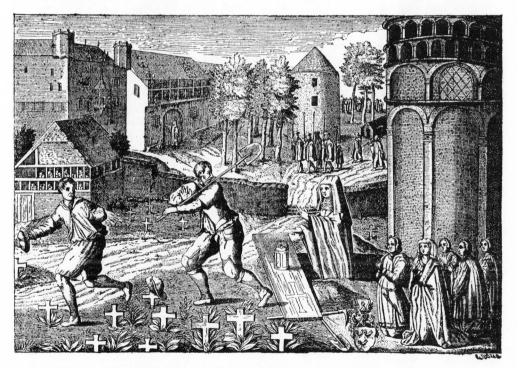

169. Ghost cotillion of the souls of Black Death victims who were buried alive in 1347. From an engraving by A. Aubrey, Germany, 1604.

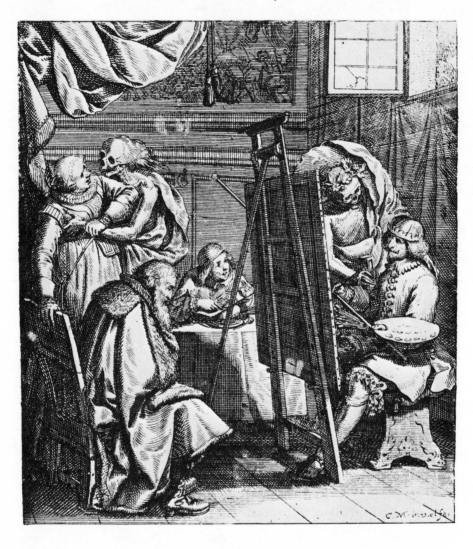

170. Death and the artists. Designed by Conrad Meyer, from Rudolf Meyer's *Sterbespiegel* (Mirror of Dying), Zurich, 1650.

171. Death on the barricades in the March Revolution, 1848. From a Danse Macabre series by Alfred Rethel.

Memento Mori

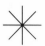

A memento mori (Latin for "remember that you must die") is an object or pictorial symbol associated with death. Such symbols include skulls, bones, coffins, urns, angels of death, upside-down torches, graves and gravestones, hourglasses, scythes, spades, toads, serpents, worms, owls, ravens, cypresses, weeping willows, tuberoses, parsley, and many more. A good number of these associations (and of our present-day funeral practices) can be traced back to antiquity. These emblems of mortality have long been used as items of adornment: Mary, Queen of Scots, owned a skull-shaped watch; Martin Luther had a gold ring with a death's-head in enamel; even today skull motifs are used in all sorts of jewelry and bric-à-brac.

172. Scribes counting the severed heads of slain enemies after a battle. After an Assyrian-Babylonian wall relief, Konyunjic Palace.

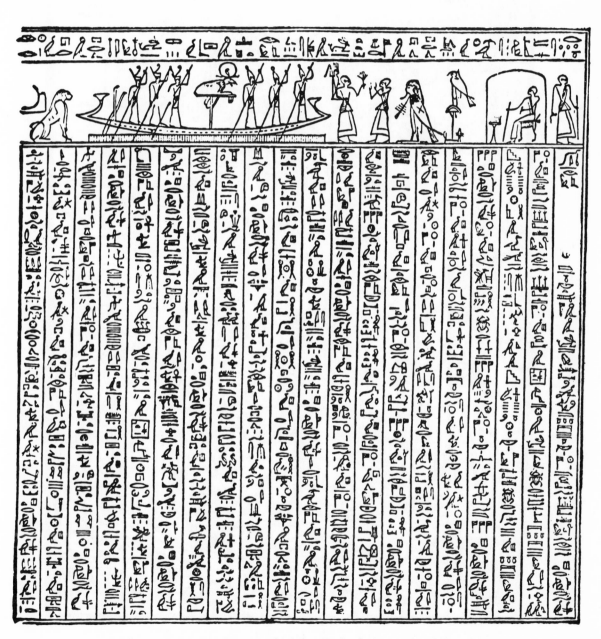

173. Page from an Egyptian papyrus *Book of the Dead,* which was placed into the tomb with the mummies as a guide for the souls of the departed.

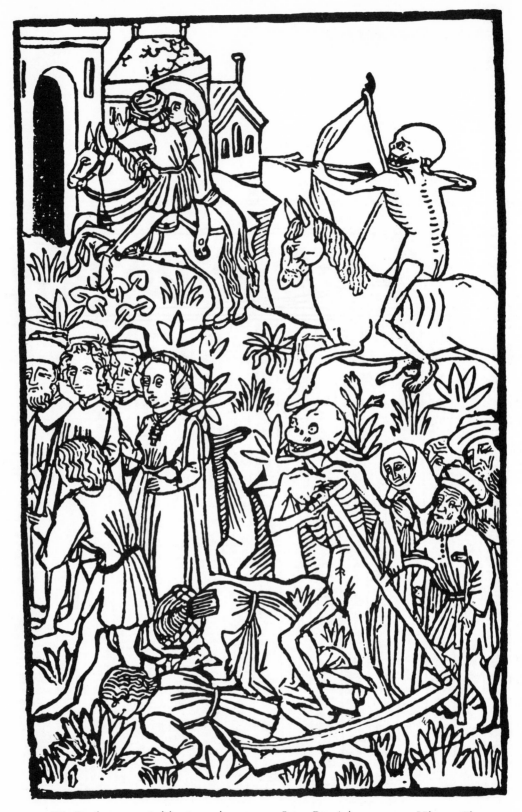

174. Death as mounted hunter and as reaper. From *Der Ackermann aus Böhmen* (The Ploughman from Bohemia), Bamberg, 1463.

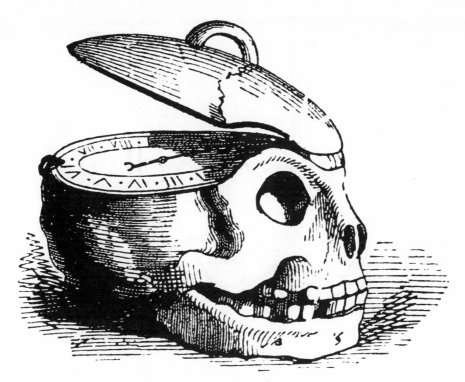

175. A skull-watch.

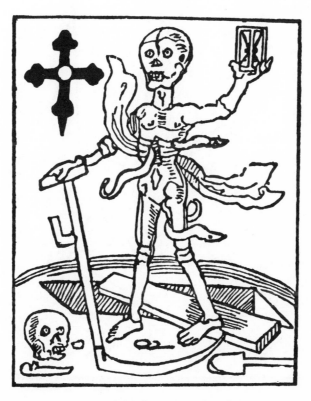

176. One of the earliest extant printed labels for a poison bottle, representing Death as a worm-eaten corpse. By an unknown Rhenish artist, 1480–90.

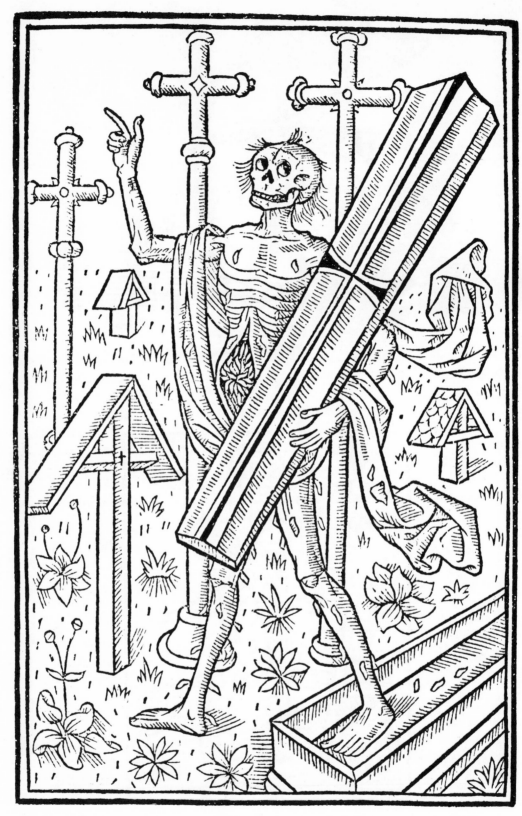

177. Allegoric representation of Death. From *Le grant kalendrier et compost des Bergiers,* printed by Nicolas le Rouge, Troyes, 1496.

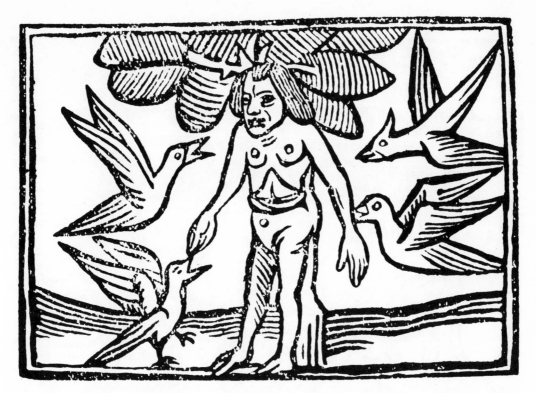

178. The Tree of Death (burial tree on the Island of Caffolos). From Sir John Maunde-
ville's *Travels,* printed by Wynkyn de Worde, London, 1499.

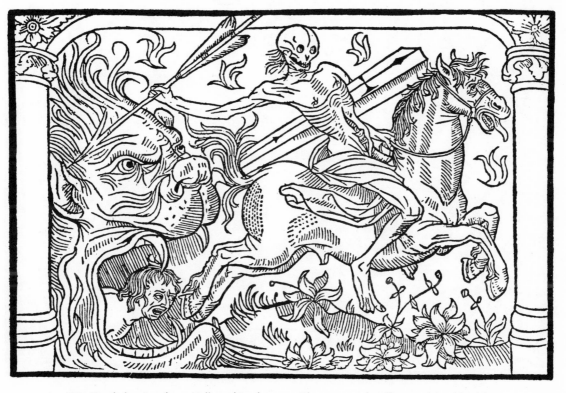

179. Death leaping from Hell on his charger with arrow and coffin, to claim his rights
over mortals. From *Le grant kalendrier,* printed by Nicolas le Rouge, Troyes, 1496.

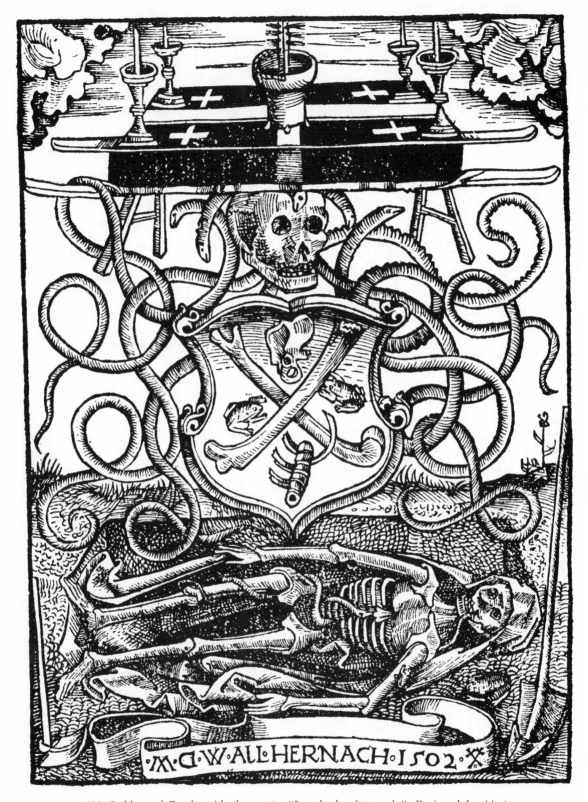

180. Emblem of Death, with the motto *"Everybody afterwards."* Designed by Master
A. F., from the *Heiligtumbuch* (Book of Relics), Vienna, 1502.

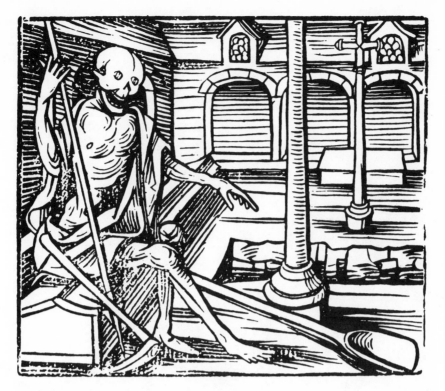

181. Death in the cloister. From Robert Gobin's *Les Loups Ravissans* (The Ravishing Wolves), printed by Antoine Vérard, Paris, 1503.

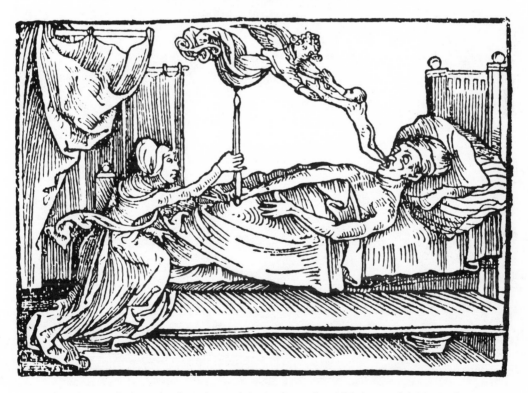

182. The Angel of Death taking the soul, in the form of a child, from a dying man. From Reiter's *Mortilogus*, printed by Oegelin and Nadler, Augsburg, 1508.

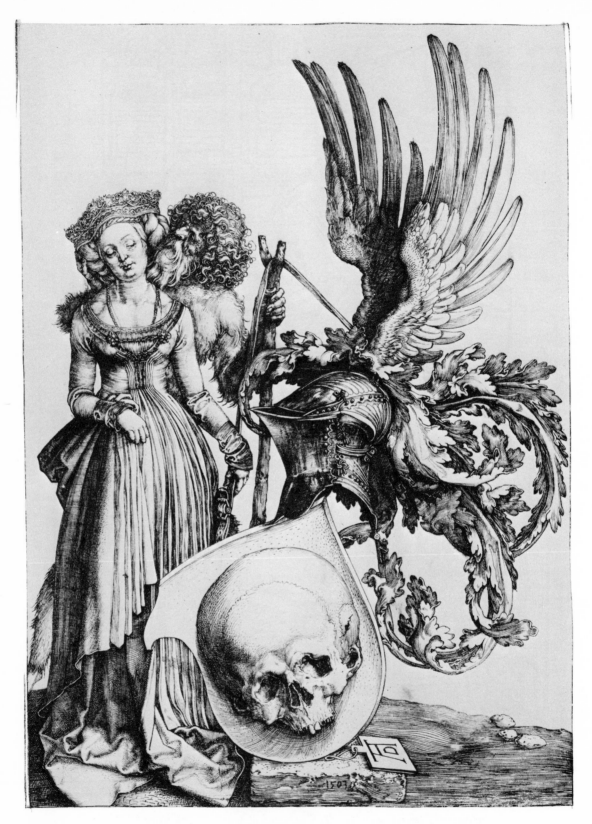

183. Coat-of-arms of Death. Engraving by Albrecht Dürer, Nuremberg, 1503.

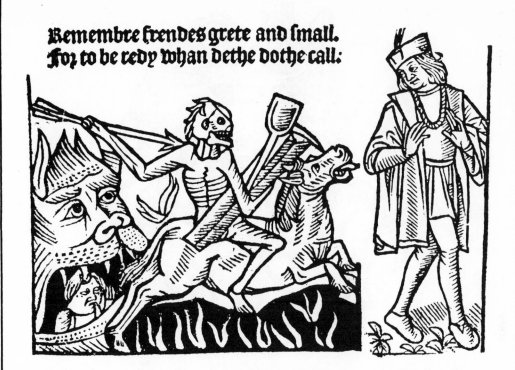

Remembre frendes grete and small.
For to be redy whan dethe dothe call:

Ow beholde and take hede & lytell /and en-
noye ne greue ꝑ not at these thre thynges.
Therfore to knowe and wyll to hate synne
forgete thy body one tyme in the daye & go
to hell lyuynge /to thende that ꝑ go not thy
der at thy dethe. Thus doone ofte the good men & ꝑ wy
se. There ꝑ shalte se all that the herte hateth /colde /hete /
honger /thyrst /and dyuers tourmentes / as wepynges
syghes /and waylynges /that the herte may not thynke
ne tonge deuyse /& alway shall endure without ende /&
therfore is this payne by right called perdurable /which
is alwaye dethe in lyuynge /and lyfe in dyenge /whan ꝑ
shalte se thenne that this one deedly synne muste nedes
be so dere bought /thou haddest leuer be slayne al quycke
wfore thou sholdest consente for to doo one onely synne.

❀ ᙁ·ᴌ

184. Death leaving the mouth of Hell and hunting a victim. From *The Boke named the Royal*, printed by Wynkyn de Worde for William Caxton, London, 1507.

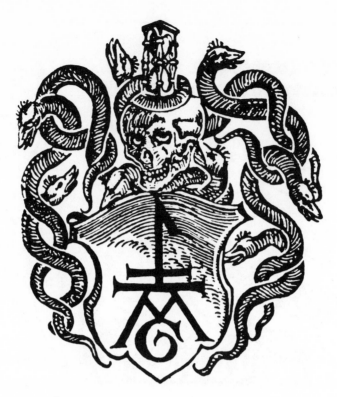

185. Macabre printer's device, using serpents, skull and hourglass as symbols of Death. The mark of Andreas Gesner, Zurich, 1550.

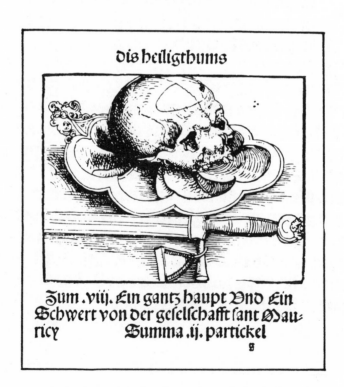

186. Relic monstrance in the form of skull and sword, symbol of the Society of Mauricius. From Lucas Cranach the Elder's *Heiligthums Buch,* Wittemberg, 1509.

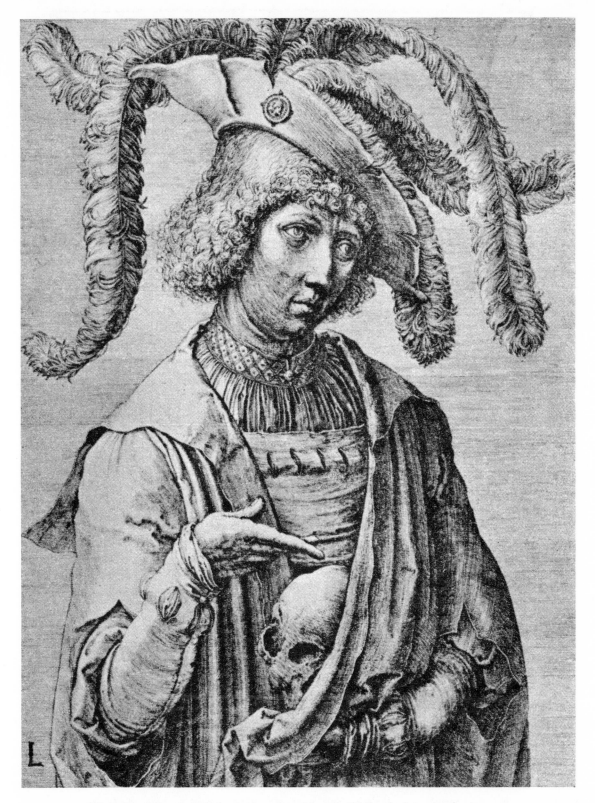

187. Hamletesque design of a young man with a death's-head. Engraving by Lucas van Leyden, 1519.

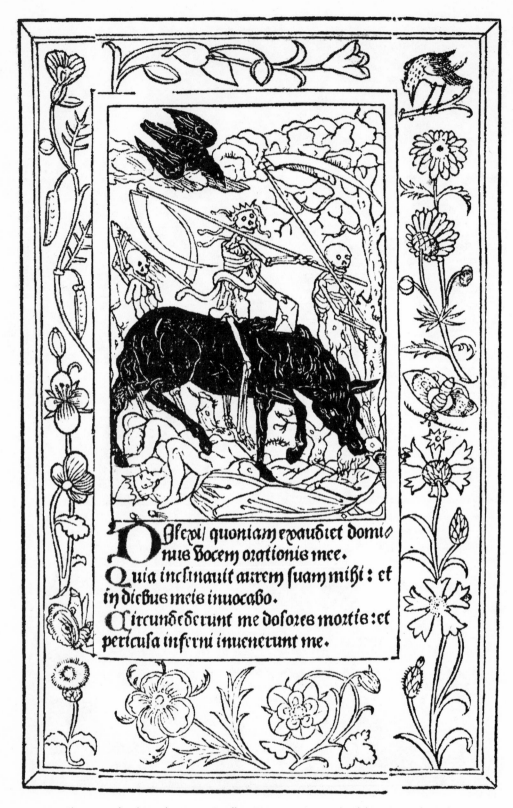

188. The triumph of Death. From Geoffroy Tory's *Horae*, printed by Simon de Colines, Paris, 1525.

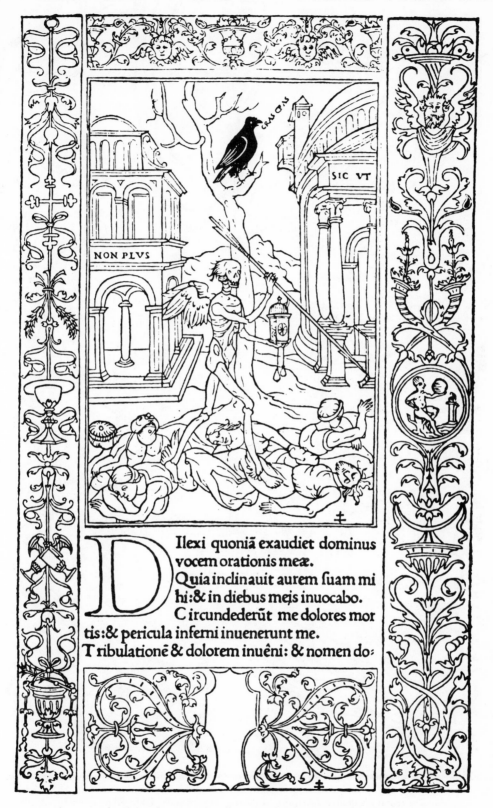

189. The triumph of Death. From Geoffroy Tory's *Horae in laudem beatissime virginis Marie,* printed by Simon du Bois, Paris, 1527.

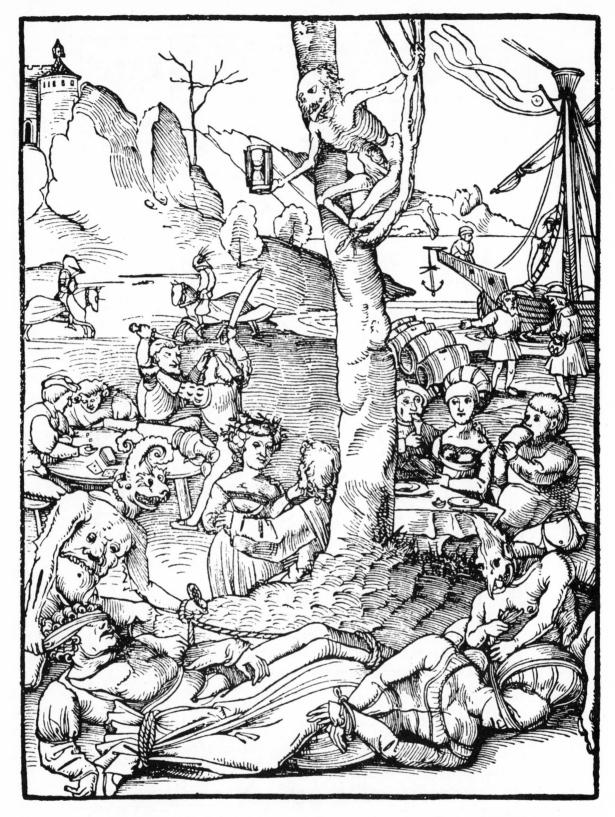

190. Death and his demonic helpers are lurking everywhere. From Elluchasem Elimithar's *Schachtafeln der Gesundheyt*, illustrated by Hans Weiditz, printed by Hans Schott, Strassburg, 1533.

191. Macabre monumental brass plate from the vault of Bishop Schonberg, Naumburg, 1576.

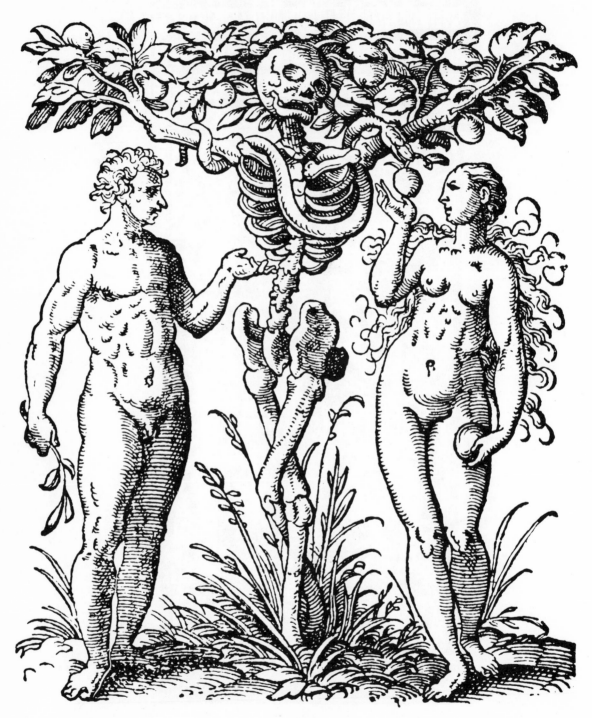

192. Macabre representation of the Tree of Knowledge and Death. Woodcut by Jost Amman, from Jacob Rueff's *De conceptu et generatione hominis,* printed by Peter Fabricius, Frankfurt, 1587.

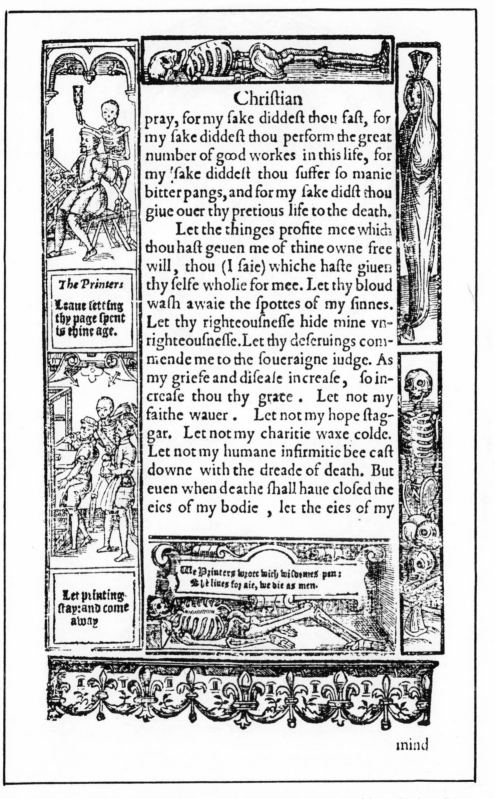

Christian

pray, for my sake diddest thou fast, for my sake diddest thou perform the great number of good workes in this life, for my 'sake diddest thou suffer so manie bitter pangs, and for my sake didst thou giue ouer thy pretious life to the death.

Let the thinges profite mee which thou hast geuen me of thine owne free will, thou (I saie) whiche haste giuen thy selfe wholie for mee. Let thy bloud wash awaie the spottes of my sinnes. Let thy righteousnesse hide mine vn-righteousnesse. Let thy deseruings commende me to the soueraigne iudge. As my griefe and diseale increase, so increase thou thy grace. Let not my faithe wauer. Let not my hope staggar. Let not my charitie waxe colde. Let not my humane infirmitie bee cast downe with the dreade of death. But euen when deathe shall haue closed the eies of my bodie, let the eies of my

The Printers

Leaue setting thy page spent is thine age.

Let printing stay: and come away

We Printers wrote with wisdomes pen: Al liues for aie, we die as men.

mind

193. Prayer for the dead. From *A Book of Christian Prayers,* printed by Richard Yardley and Peter Short for Richard Day, London, 1590.

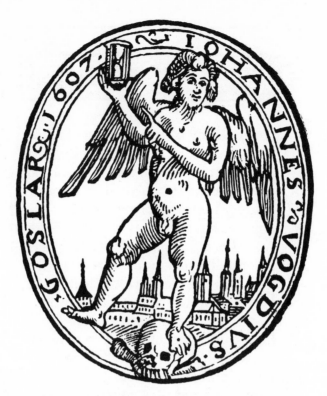

194. The winged Angel of Death with skull and hourglass. Printer's device of Johann Vogt, Goslar, 1607.

195. Relic monstrance in the shape of a skull and thighbone. Engraving by Christoffel van Sichem, from *Het geheele leven ons Heeren Jesu Christi,* printed by P. I. Paets, Amsterdam, 1648.

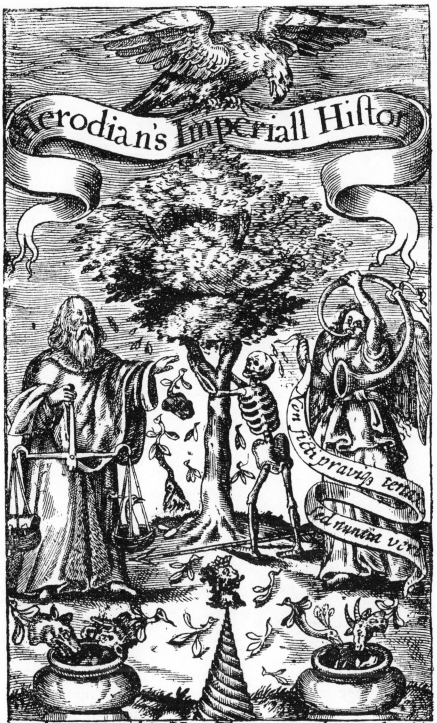

196. Title page with allegoric representation of the Judgment of Fame after Death. From Herodian of Alexandria's *Imperial History*, published by Henry Taunton, London, 1635.

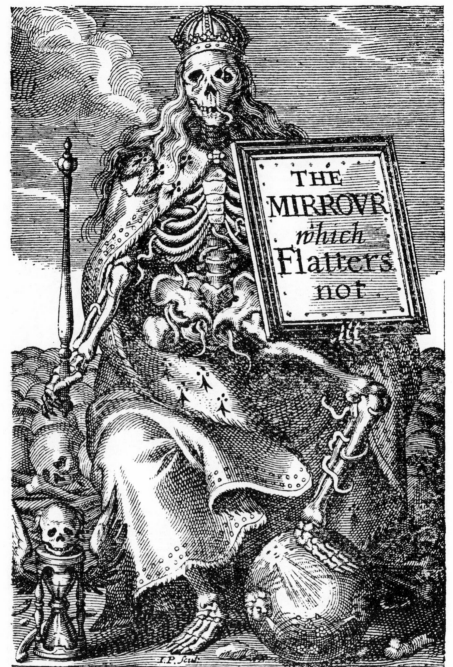

197. Symbolic-emblematic representation of the transitoriness of might. From T. Carey's
The Mirrour which Flatters not, published by R. Thale, London, 1639.

198. Macabre calligraphic page with emblems of Death. From a work by Francesco Pisani, Genoa, 1640.

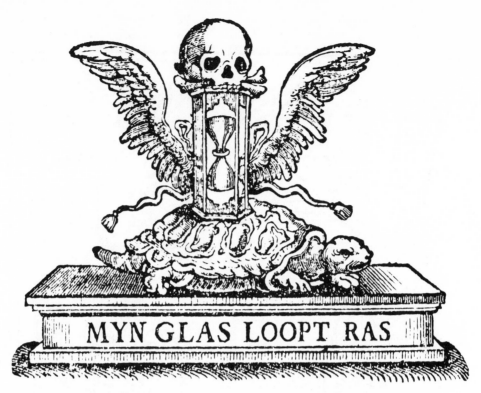

MYN GLAS LOOPT RAS

199. Symbol of Death with the motto "My glass runneth quickly." Printer's device of Joost Hartgers, Amsterdam, 1651.

200. Alchemical allegory of putrefaction. From Basil Valentine's *Azoth*, Paris, 1659.

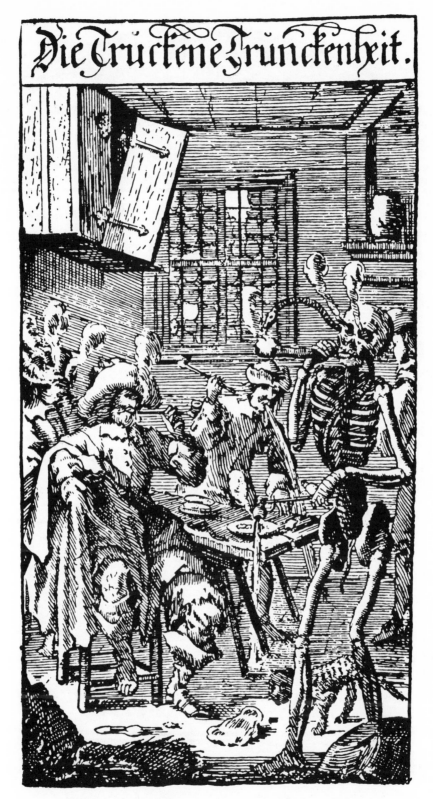

201. The deadly demon of tobacco "drinking." From Jacob Balde's anti-smoking pamphlet *Die Truckene Trunckenheit* (The Dry Drunkenness), printed by Michael Endter, Nuremberg, 1658.

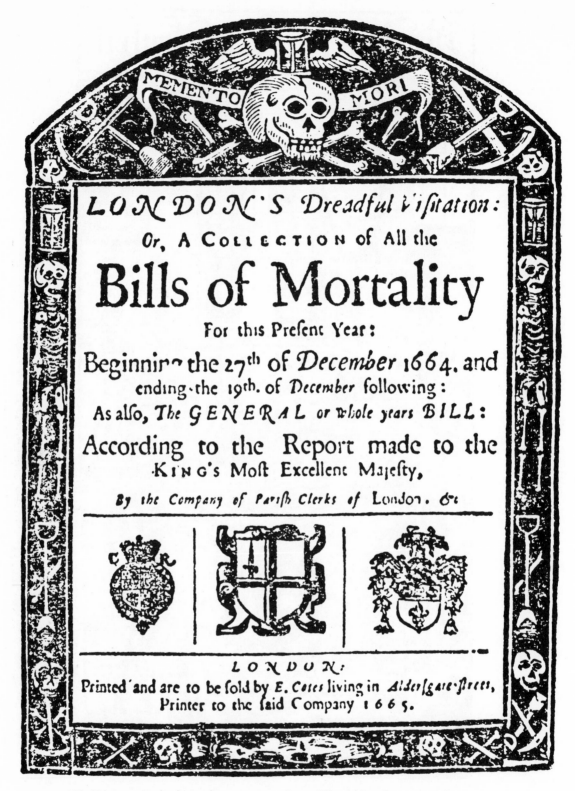

202. Title page in the form of a gravestone. From *Bills of Mortality,* a printed report to the king about the people who died of the plague from December 1664 to December 1665, printed by E. Cotes, London, 1665.

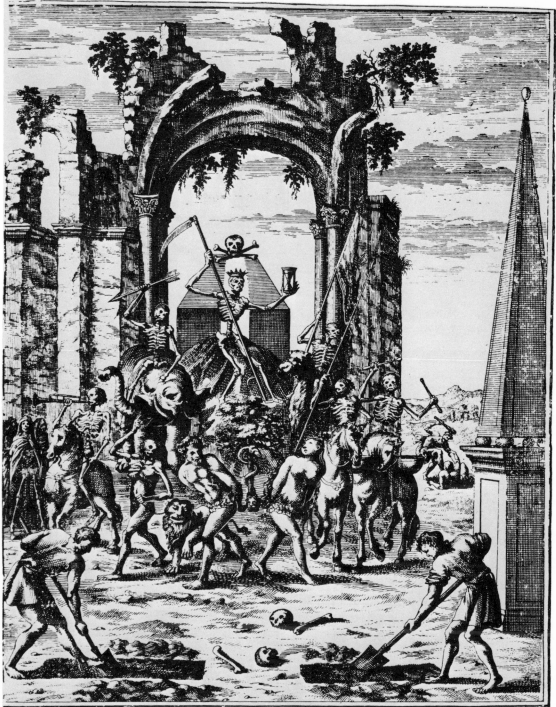

W. W. inuen W excud. Jo: Koch del: And: Trost sculp: Wagenpurgi in Carniolia

203. "The Triumphal Arch of Death." Engraving by Anders Trost after Johann Koch, from Johann Vavasor's *Theatrum mortis humanae,* Ljubljana, 1682.

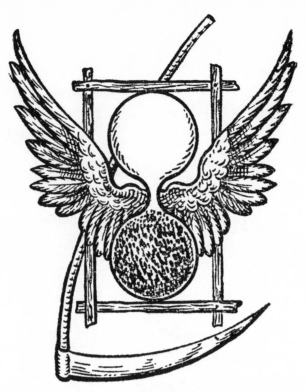

204. The winged hourglass and the scythe, symbolizing the flight of time and the certainty of death. From a Rosicrucian emblem book, seventeenth century.

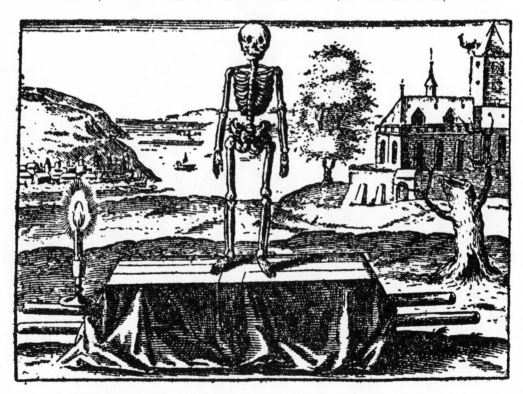

205. The skeleton on the casket and the broken tree stump symbolize Death, and the burning candle represents the human mind rising to Heaven. From a Rosicrucian emblem book, seventeenth century.

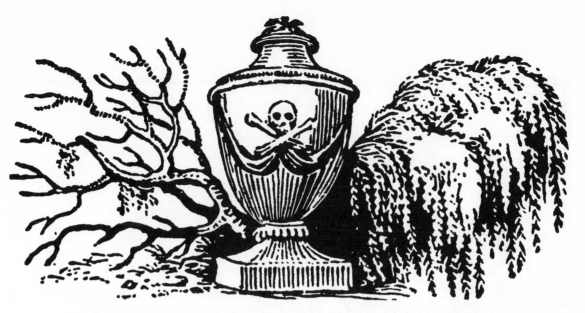

206. The urn, the leafless branch and the weeping willow as symbols of Death. By the American wood engraver Alexander Anderson (1775–1870).

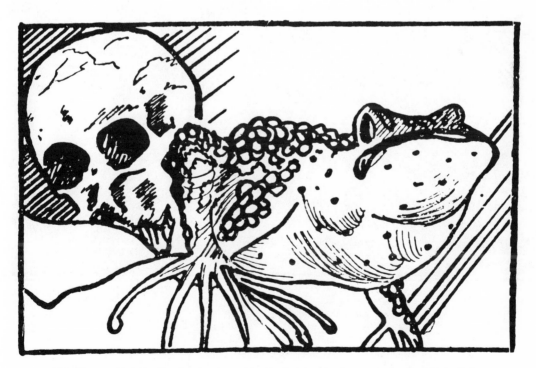

207. The toad of Death. From a pen drawing in an occult manuscript *La Magie Noire* (Black magic), France, nineteenth century.

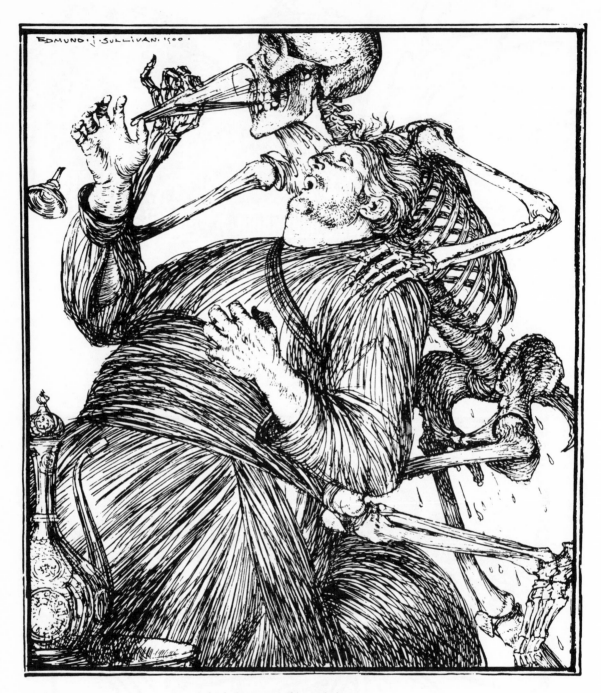

I think the Vessel, that with fugitive
Articulation answer'd, once did live,
And Merry-make; and the cold Lip I kiss'd
How many Kisses might it take—and give.

208. Macabre illustration by Edmund J. Sullivan for Quatrain XXXV of *The Rubáiyát of Omar Khayyám*, by Edward Fitzgerald, London, 1859.

Oh, come with old Khayyám, and leave the Wise
To talk; one thing is certain, that Life flies;
One thing is certain, and the Rest is Lies;
The Flower that once has blown for ever dies.

209. Macabre illustration by Edmund J. Sullivan for Quatrain XXVI of *The Rubáiyát of Omar Khayyám*, by Edward Fitzgerald, London, 1859.

Resurrection and Reckoning

In Christian belief, Christ rose from the dead, and on Judgment Day, the last day of the world, everyone who ever lived will awaken from the dead and be tried by the Lord and His angels. Many great works of art have been based on this theme.

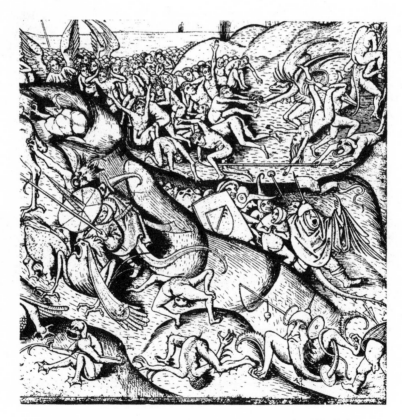

210. Detail from "The Last Judgment." Engraving by Allard du Hameel after Hieronimus van Aeken Bosch.

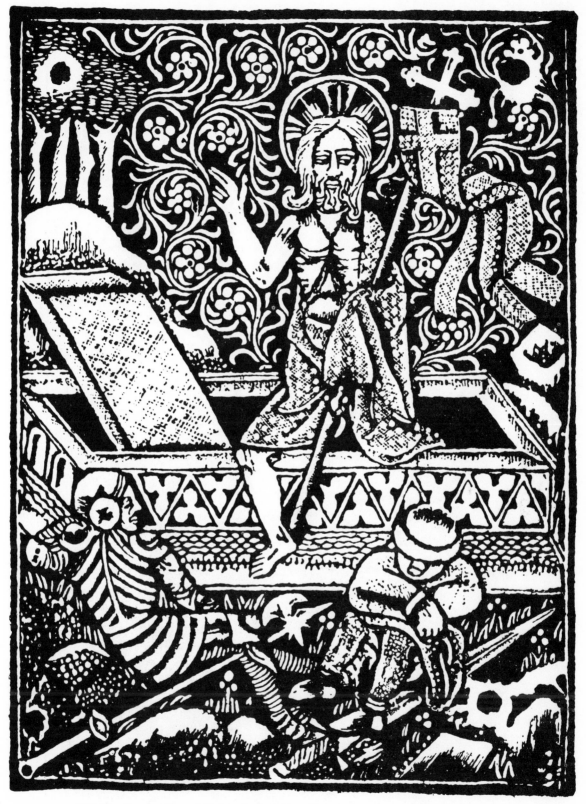

211. The Resurrection of Christ. From *Leiden Christi* (The Passion of Christ), printed by
Albrecht Pfister, Bamberg, 1470.

212. The Last Judgment. Woodcut by Michael Wolgemut, from Hartman Schedel's *Liber Cronicarum*, printed by Anton Koberger, Nuremberg, 1493.

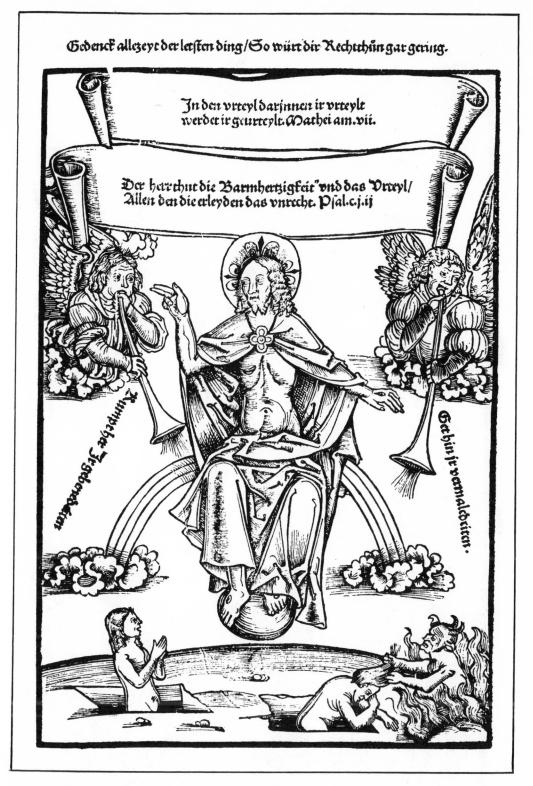

213. The Last Judgment. From the *Bambergische Halsgerichtsordnung,* 1510. The quotations are: "For with what judgment ye judge, ye shall be judged" (Matthew 7:2) and "The Lord executeth righteousness and judgment for all that are oppressed" (Psalms 103:6).

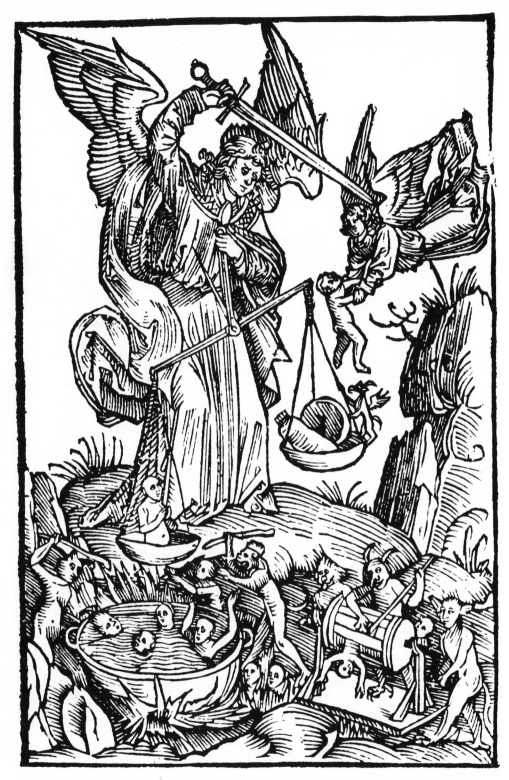

214. Weighing of souls by the Archangel Michael. Xylographic page from *Ars Moriendi,*
printed by Johann Weissenburger, Landshut, 1514.

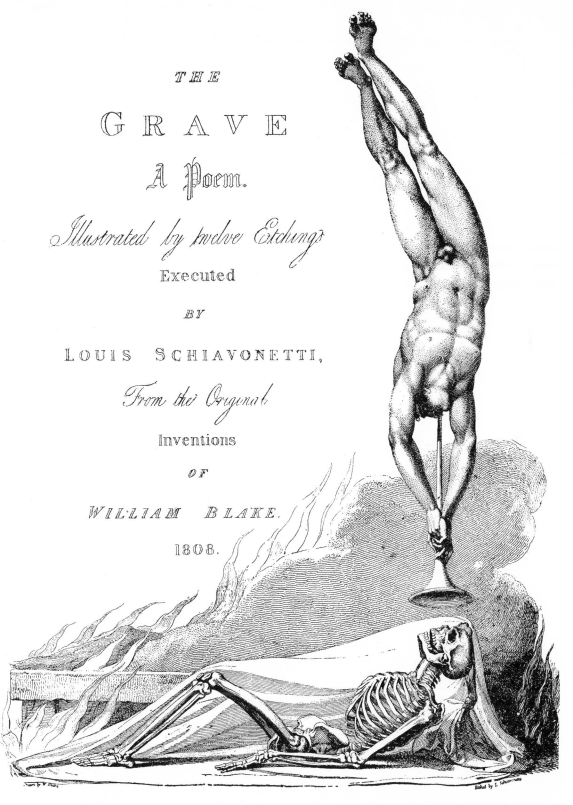

THE

GRAVE
A Poem.

Illustrated by twelve Etchings

Executed

BY

LOUIS SCHIAVONETTI,

From the Original

Inventions

OF

WILLIAM BLAKE.

1808.

215. Allegoric representation of resurrection. From Robert Blair's *The Grave*, engraved by Louis Schiavonetti after William Blake, printed by T. Bensley, London, 1808.

Religio-Political Devilry

Devils, demons and similar infernal figures (including swine) have been favorite material for religious and political pamphleteers and caricaturists of all denominations and convictions for centuries. Writers and artists attacking such real and alleged abuses as drinking, dancing, smoking, gambling, counterfeiting and usury have not hesitated to press Satan into their service. This concluding chapter presents a wide panorama of these polemic graphics with a smell of brimstone.

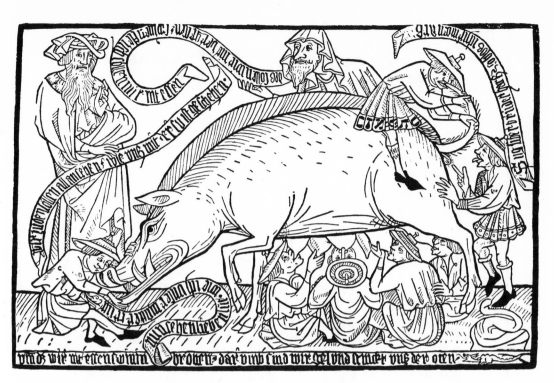

216. Jewish scholars, wearing the pointed hats forced upon them by the law, are suckled by their wetnurse, the "Devil's pig." From the earliest extant anti-Semitic broadside, Germany, 1475.

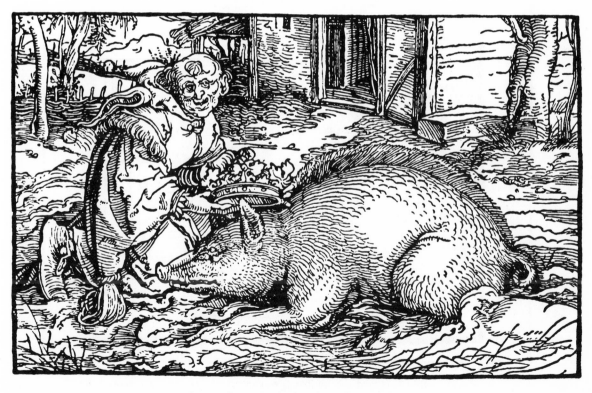

217. Papist crowning the Devil's pig. Woodcut by Hans Weiditz, from *Ciceros Officien*, printed by Heinrich Steiner, Augsburg, 1531.

wie der wurffel auff

ist kommen

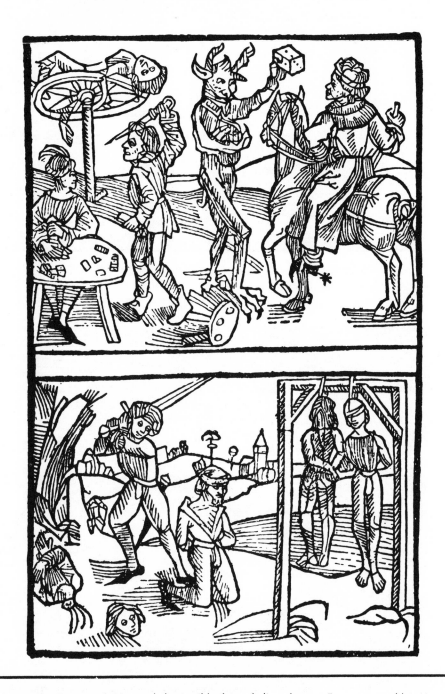

218. The Demon of Dice and the terrible fate of dice-players. From a pamphlet *How the Die Was Invented;* attributed to Albrecht Dürer, printed by Conrad Kacherofen, Leipzig, 1487.

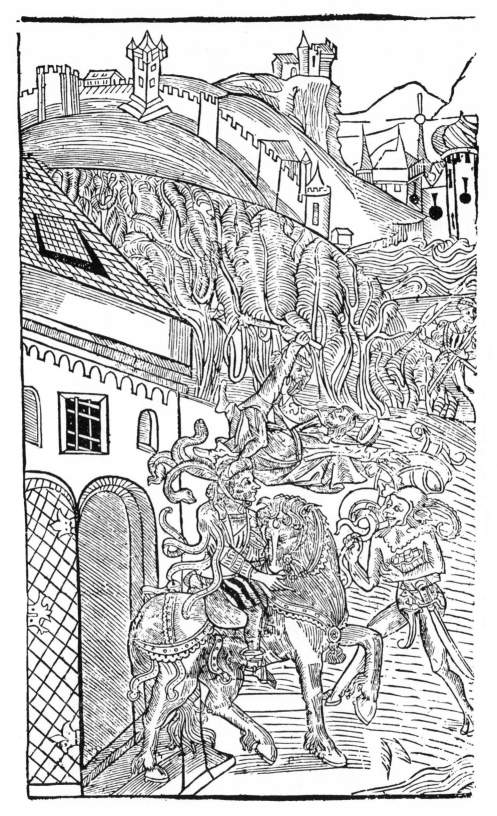

219. The Dice-Demon tempting the gambler. Detail from a broadside warning against dice-playing, France, 1490.

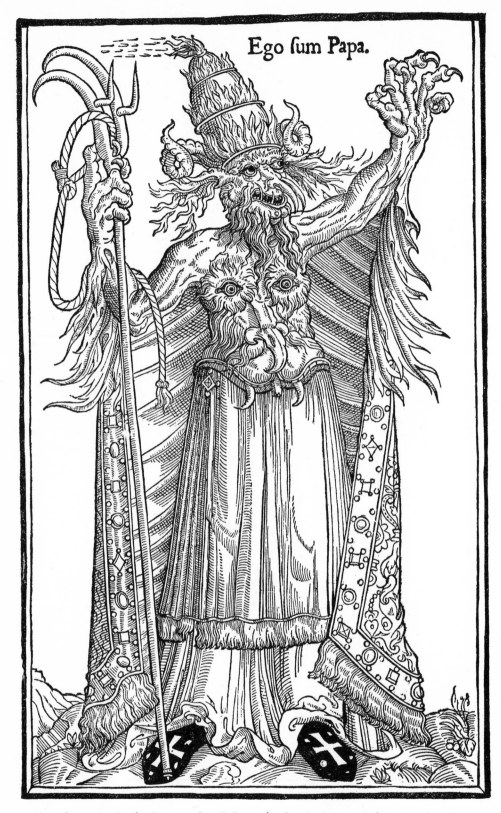

220. The Papist Devil, "Ego sum Papa" (I am the Pope). From a Reformation handbill against Pope Alexander VI, Paris, late fifteenth century.

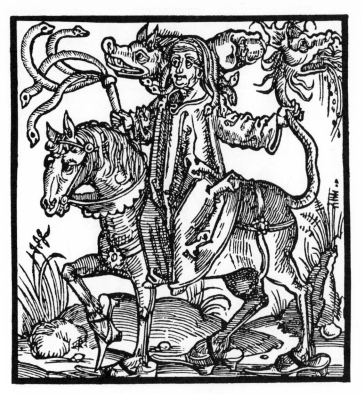

221. George Zingel, one of the Papist adversaries of the reformer Jacob Lochner, depicted as an infernal monster. From Lochner's polemic treatise *Apologia contra poetarum acerrimum Hostem Georgium Zingel*, printed by Johann Grüninger, Strassburg, 1503.

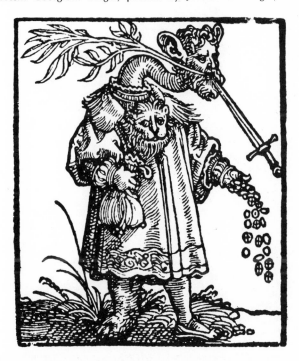

222. Demonic anti-Papist caricature. From the title page of *Opera Poetica* by the reformer Ulrich van Hutten, printed by Henri Petri, Basle, 1538.

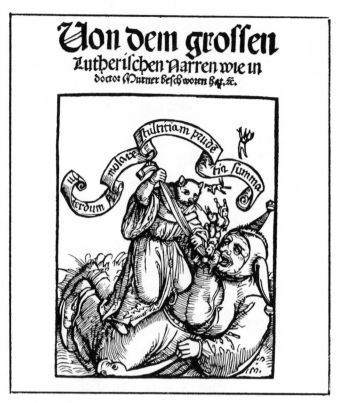

223. Title page from Thomas Murner's anti-Reformation pamphlet *Von dem grossen Lutherischen Narren* (On the Big Lutheran Fool), about 1518.

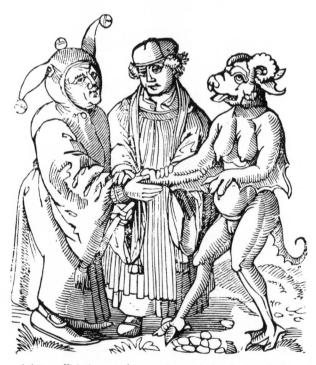

224. Reform minister officiating at the marriage of the fool and the she-devil. From Thomas Murner's anti-Lutheran pamphlet *Von dem grossen Lutherischen Narren*, about 1518.

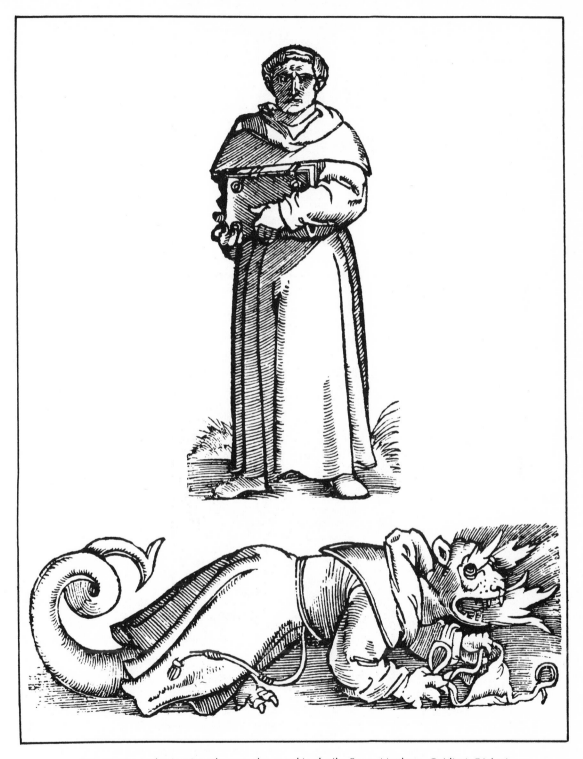

225. Martin Luther's triumph over the monk's devil. From Mattheus Gnidius' *Dialogi*,
a Reform pamphlet against the Papists Murner and Weddel, Germany, 1521.

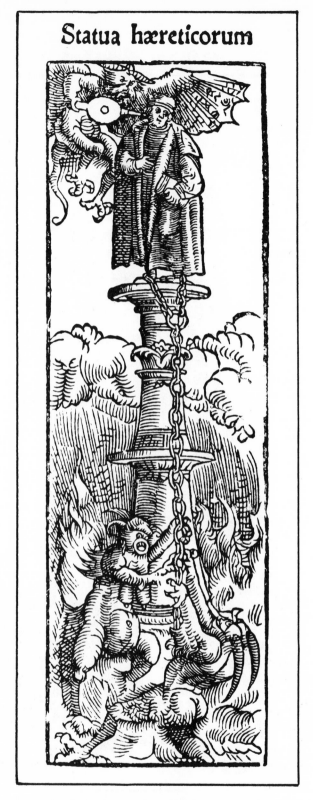

226. The Column of Heresy. From an anti-Lutheran pamphlet *Catalogus Haereticorum omnium pene*, Cologne, 1526.

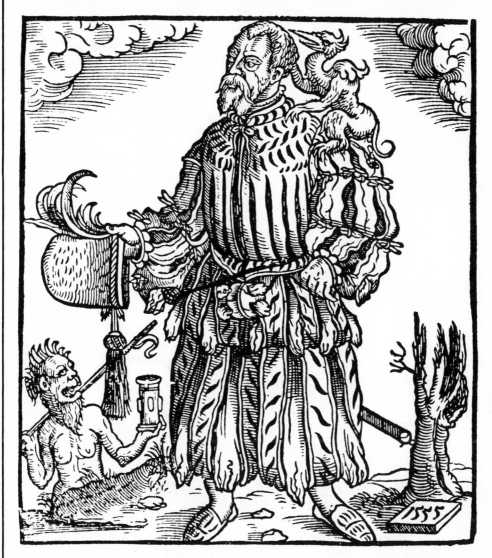

227. Title page from a conformist sermon by Andreas Musculus, *Vom Hosen Teuffel* (the disorderly, infamous and audacious devil of the long baggy breeches; an admonition and call to order), printed by Johann Eichhorn, Frankfurt am Oder, 1555.

228. The "Devil's Rotisserie." From a satiric Reformation handbill depicting the larding, stuffing and roasting of Jesuits by the Devils, designed by F. Hildeberg, Germany, 1580.

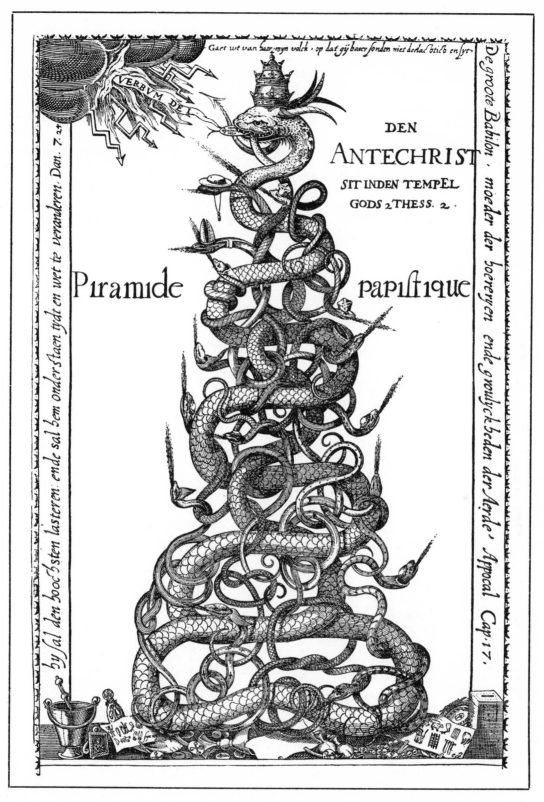

229. "Piramide papistique," satiric-allegoric representation of the Roman Church hierarchy as the Serpents of Hell. From a Protestant anti-Papist broadside, Holland, late sixteenth century.

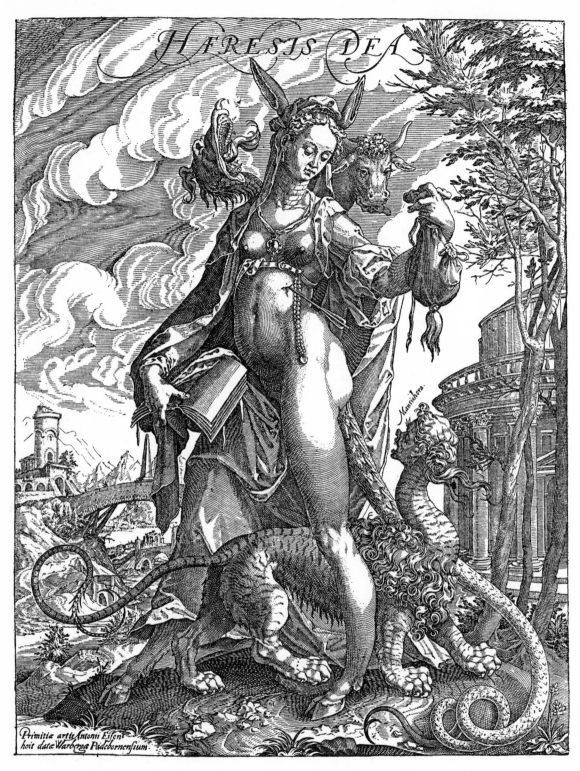

230. The Goddess Heresy. From a satiric anti-Reformation handbill designed by Anton Eisen, Paderborn, Germany, late sixteenth century.

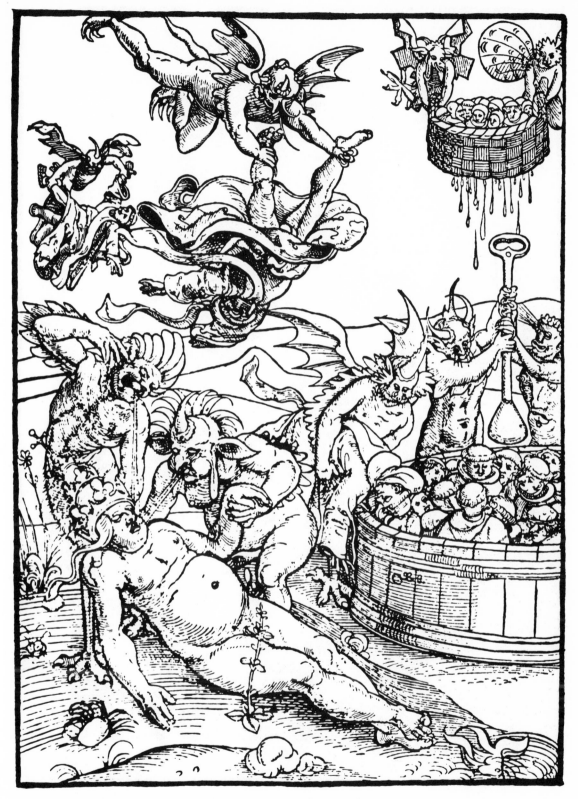

231. The Papal hierarchy as mash in the Devil's vineyard. From a German anti-Papist broadside, late sixteenth century.

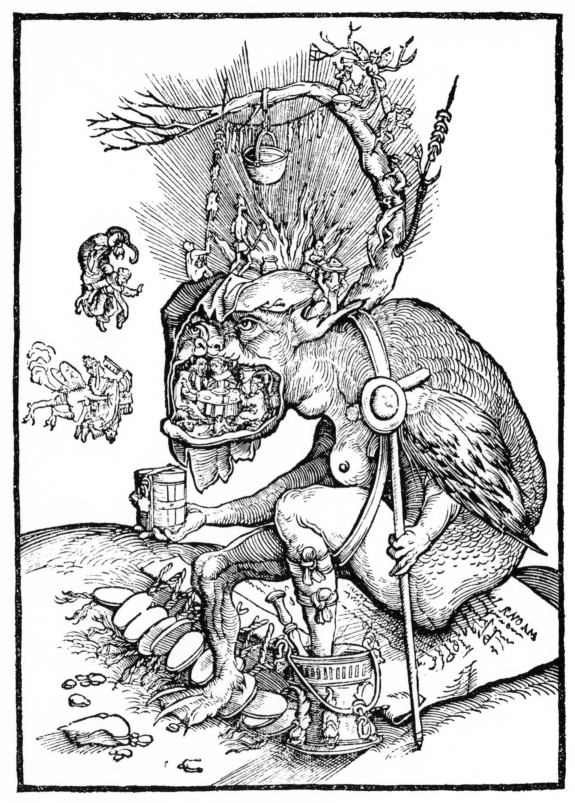

232. Papist indulgence peddlers in the jaws of Hell. From a satiric Reformation hand-
bill, Germany, late sixteenth century.

THE
SCOVRGE
OF
DRVNKENNES.

By *William Hornby* Gent.

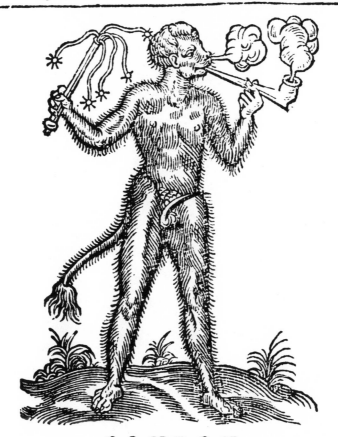

LONDON,
Printed by G. E l d, for *Thomas Baylie,* and are to be folde
at his Shop, in the Middle-Row in Holborne,
neere vnto *Staple-Inne.* 1 6 1 8.

233. The Devil of tobacco "drinking." From William Hornby's *The Scourge of Drunken-nes,* an anti-smoking pamphlet printed by G. Eld for Thomas Baylie, London, 1618.

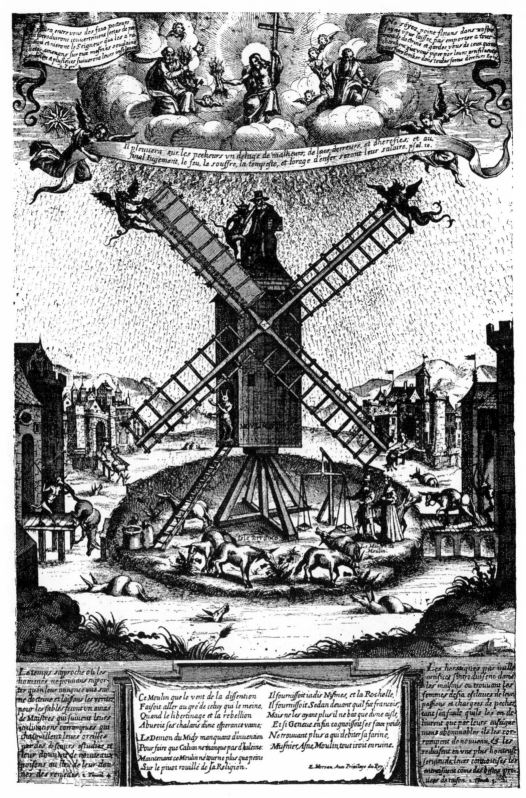

234. The Devil's mill of discord. From an anti-Huguenot handbill printed by E. Moreau, Paris, 1630.

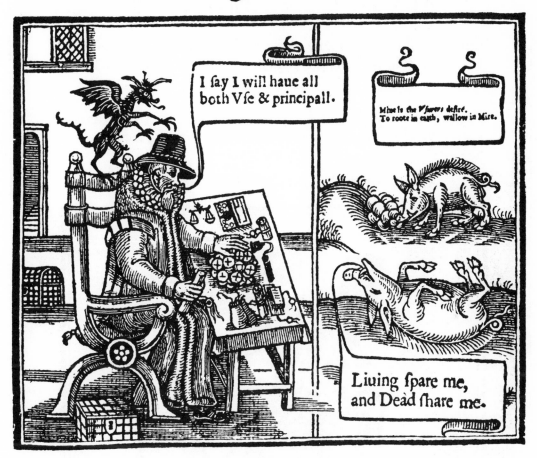

235. The Devil of Usury. From John Blaxton's pamphlet against loan sharks, *The English Usurer*, printed by John Norton for Francis Bowman of Oxford, London, 1634.

THE
DEVIL TURN'D
ROUND-HEAD:

OR,
PLVTO become a BROWNIST.

Being a juft comparifon, how the Devil is become a *Round-Head?* In what manner, and how zealoufly (like them)
he is affefted with the moving of the Spirit.

With the holy Sifters defire of Copulation (if he would
feem Holy, Sincere, and Pure) were it with the Devill
himfelf.

As alfo, the Amfterdammian definition of a Familift.

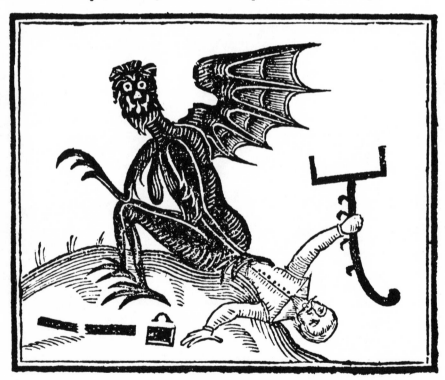

236. The Round-head Devil. From an anti-Puritan pamphlet by John Taylor, *The Devil
Turn'd Round-Head,* London, 1642.

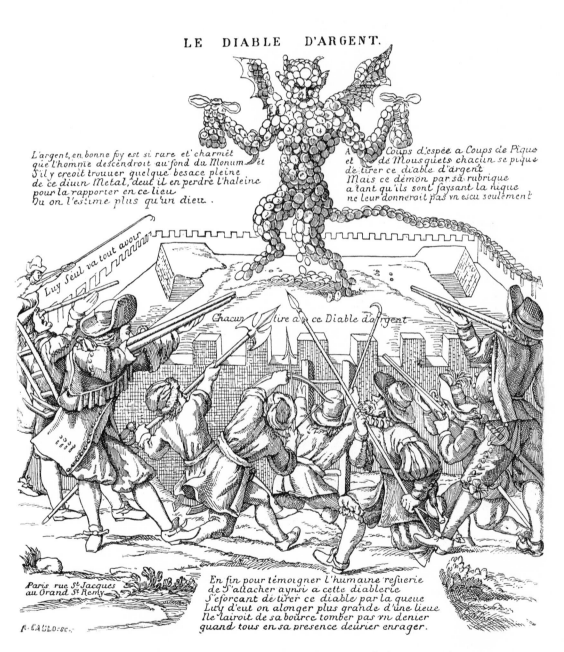

237. The Money Devil. From a satiric handbill against loan sharks, France, about 1650.

238. Pluto, the Papist Devil, falling sick over the order of the so-called Long Parliament to deface all Romanistic churches and to destroy all their idolatrous images. From the pamphlet *A Dreame; or, Newes from Hell,* anonymously printed in London, 1641.

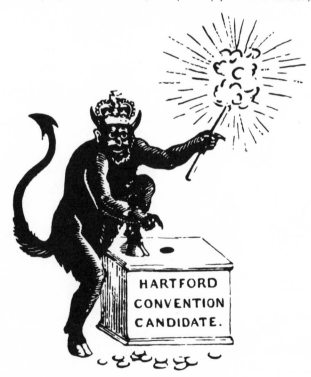

239. The Hartford (Connecticut) Federalist Convention candidate (the Imperial Devil). From an anti-British campaign leaflet for James Monroe printed in New England, 1812.

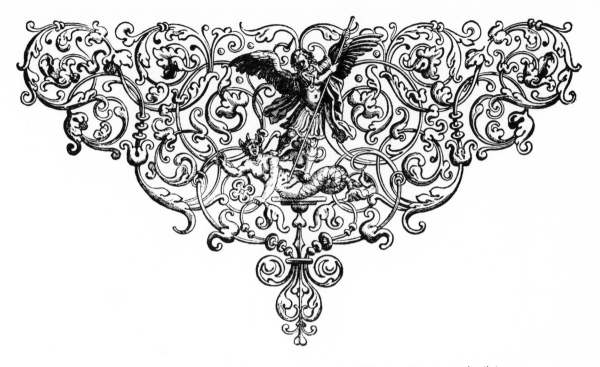

240. St. Michael casting Lucifer, the power of sin, out of Heaven. Ornamented tailpiece from a French book printed in 1650.

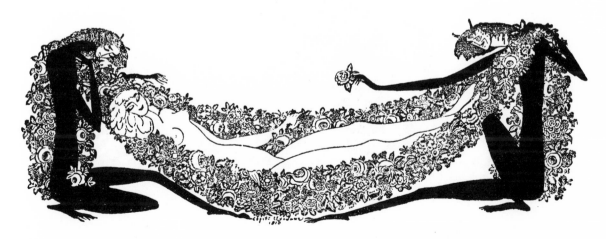

241. Incubi inducing sweet sexual dreams in a sleeping girl. Designed by S. Tschechonin for the Russian periodical *Satyricon,* St. Petersburg, 1913.

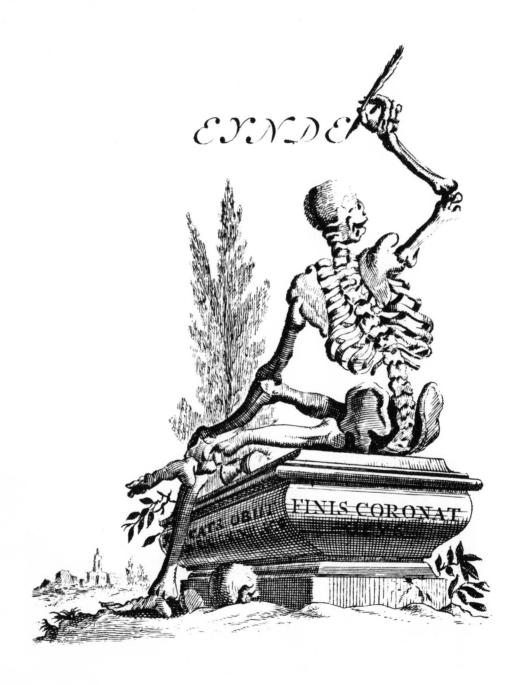

242. Final page, "Finis coronat" (the end crowns [the work]). From Jacob Cats' autobiographical poem *An Eighty-Two-Year-Long Life*, published by Jan van der Deyster, Leyden, 1732.